Oil Painting Medic

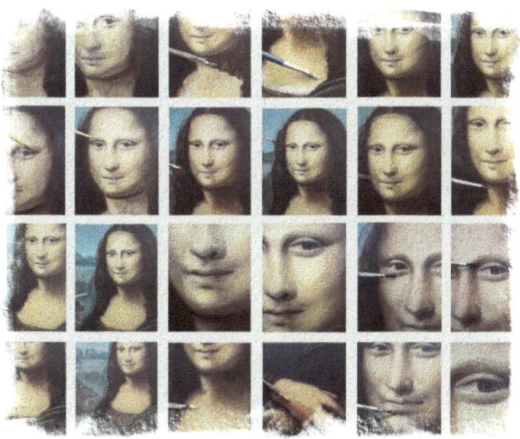

Oil Painting the Mona Lisa in Sfumato
A Portrait Painting Challenge in 48 Steps

Rachel Shirley

ISBN-13: 978-1492753469
ISBN-10: 1492753467

First Published in 2013 by Rachel Shirley

Text, photographs and illustrations copyright Rachel Shirley 2013. All rights reserved.

The Right of Rachel Shirley to be identified as the author of this work has been asserted in accordance with the Copyright Designs and Patents Act 1988 Section 77 and 78.

To my family

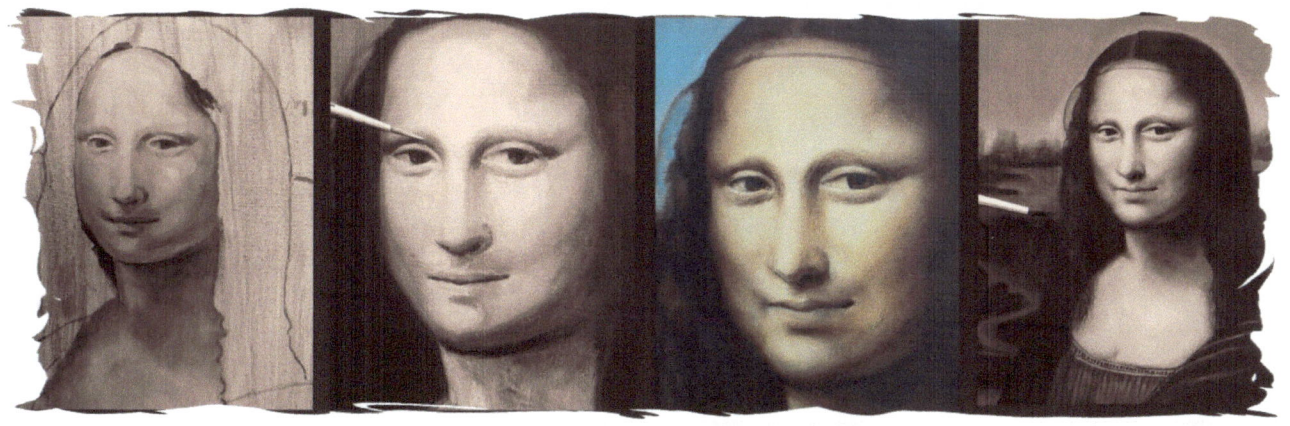

Contents

	Introduction	4
	What is Sfumato?	6
	Preparing to Paint the Mona Lisa	8
Stage 1	The Underdrawing and the Underglaze	12
Stage 2	The Underpainting	14
Stage 3	The Chief Glaze	22
Stage 4	The Dry Brushing	32
Stage 5	The Background	38
	The Finished Painting	40
	What Went Wrong?	41
	Glossary	43
	Other books by the author	45

Introduction

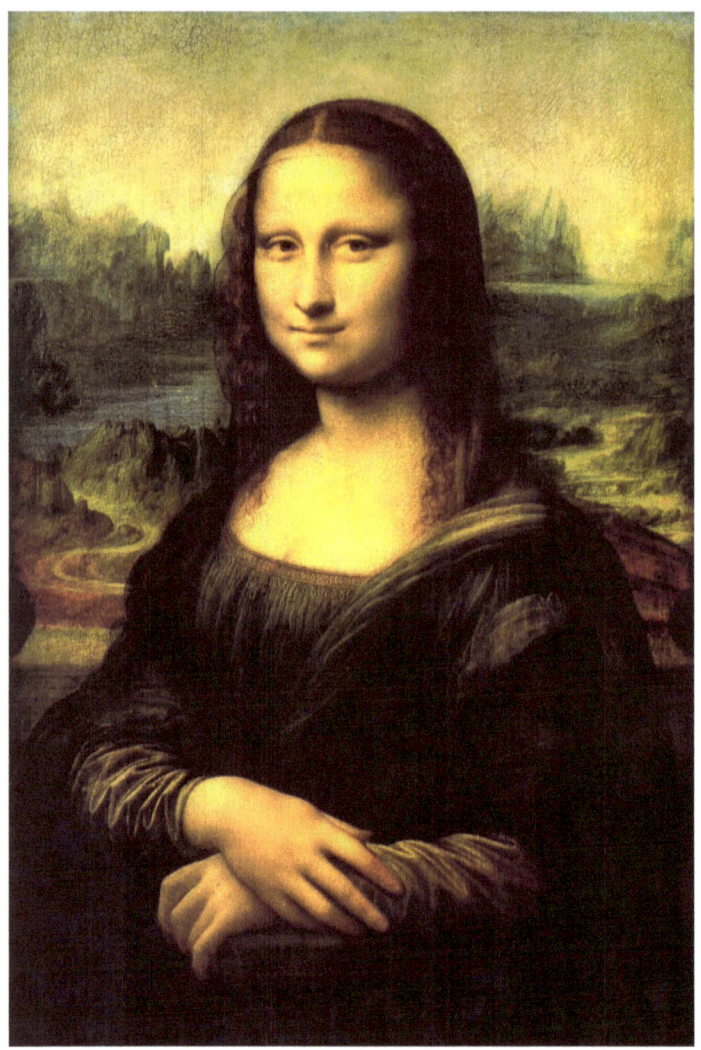

Leonardo da Vinci's masterpiece the Mona Lisa is arguably one of the high achievements of portraiture. Reproductions do not convey how small the painting actually is, being 30.25x 20.75in. Millions have visited the Louvre in Paris, to say that they have seen the painting in real life, but few may consider actually painting it, viewing such a challenge too much to take on. This book aims to make such a challenge more possible.

Leonardo in fact has few paintings to his name, so what makes this painting different to the creations of his contemporaries? The subject matter, Lisa Gherardini the wife of a Florentine merchant could easily be consigned to obscurity had it not been for Leonardo's unique treatment in painting her around 1503.

Also known as La Gioconda, the Mona Lisa comprises an astonishing array of tonal values with indiscernible edges that come together to form a facial expression. Her smile would seem to lie at the junction of several emotions: amusement, condescension, pride, delight, conceit, knowingness and others less definable.

The uniqueness of this painting means that any artist who paints the Mona Lisa will result in a slightly different outcome; perhaps one with more amusement or knowingness than is shown in Leonardo's original. The aim of this project is not to simply make a carbon copy of Leonardo's painting, as this is not this book's intention, but to help the developing portraitist push out the boundaries of portrait painting and learn something along the way.

This brings me to the other notable feature of this painting, which is Leonardo's sfumato technique, at the time, a pioneering mode of painting that defines one of the Renaissance styles. For any portraitist, mastering sfumato could prove invaluable for future portrait painting.

This book outlines in depth how this oil painting was completed, providing a workout for any portraitist.

Numerous images accompany full instructions with tips and extra features. It must be noted here, that this book does not explain the painting processes of the Renaissance period such as grinding pigments or the old masters' method of underpainting. Aside from such a momentous task this would pose, could exclude artists who do not have the room or the resources to prepare in such a way.

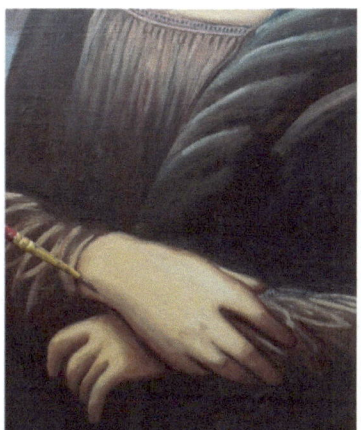

This book's aim is to make painting the Mona Lisa more inclusive. This means getting on with the painting with minimal fuss. Contemporary art materials and modified art techniques have been used in this book. I feel that the end result is more important than what went on before. However, this book offers a way of achieving sfumato effects in the style of Leonardo da Vinci.

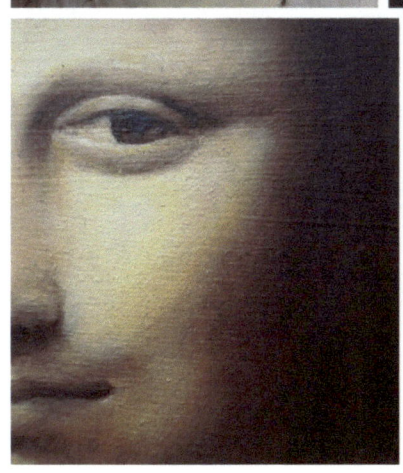
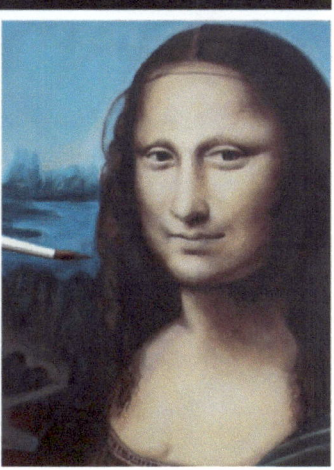

Painting the Mona Lisa via sfumato technique is included within my other art instruction book, *Skin Tones in Oil Colour: 10 Step by Step Guides from Old Masters*. However, since this demonstration has proved to be quite complex and lengthy, felt it warranted a book in its own right. This book has extra features regarding this demonstration, should the artist wish to explore painting this masterpiece alone.

The portraitist may discover that learning sfumato techniques is valuable for future portrait painting, as (in my experience) have inadvertently applied sfumato on numerous cheekbones, brows and chins over the years.

Now, having mentioned sfumato several times here, what does it mean and how can it be achieved?

What is Sfumato?

Sfumato comes from the Italian word *sfumare*, which means to evaporate like smoke. One only has to carefully inspect the Mona Lisa to see the subtle gradations between light and dark – like smoke. There are few distinguishable lines, only implied contours within ethereal shadows. It would be almost impossible to pin down the edges of the face, only to make rough approximations.

This book attempts to explain how sfumato can be achieved via in-depth step by step instructions and associated images of the painting in progress. Not only will this exercise build artist confidence but develop painting skills, particularly in portraiture.

Sfumato is not easy but is made achievable with the right art materials, time and patience. Practice is also the key. Sfumato can in fact be achieved in mediums other than oils, but each has certain drawbacks. Pastel pencils for instance is great for shading techniques but lacks the scope for colour mixing like paints. Acrylics are ideal for glazing techniques but the paint does not remain workable for long. This makes oils the ideal medium with which to explore sfumato.

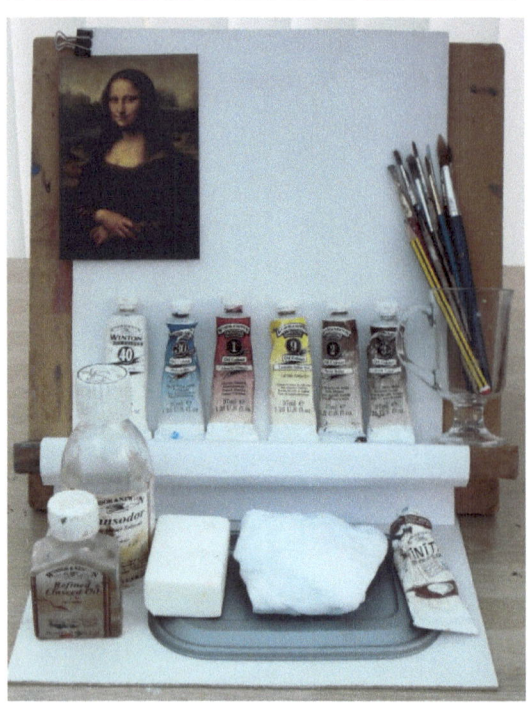

Art materials required for sfumato comprise just 6 oil colours, brown acrylic paint, fine sables, basic mediums and rags.

Art Materials for Sfumato

Just a handful of art materials have been used in this project. The image shows: the oil colours, titanium white, cadmium yellow, alizarin crimson, burnt sienna, burnt umber and pthalo blue. I use an assortment of brushes, predominantly fine sable nos. 3, 6 and 10 rounds and a couple of bristles, mainly fine and medium. Also used are linseed oil and odorless artist spirits. Ready-sized art panels can be purchased from the shops but I prepared my own by applying two coats of gesso size over a piece of MDF measuring 10x12in. Between each coat, I lightly sanded the surface to knock off any grittiness. Alternatively, a ready-primed panel can be purchased from an art store, but avoid using canvas as the texture will interfere with the subtle effects of sfumato. Its textured surface also means a larger quantity of paint is needed which will prove inconvenient when trying to attain delicate shades.

Any non-porous material can be used for a mixing palette. I used a discarded plastic Tupperware lid. Clingfilm can be stretched over the top via bulldog clips for easy disposal of the dirty palette. An old rag, a bar of soap and a pencil will come in useful. Brown acrylic paint will lastly be needed for the imprimatura, a translucent underglaze that kills the whiteness of the art surface.

As can be seen from the images here, my art materials are well-used and simple. When it comes to obtaining soft, shaded effects of sfumato, I prefer a brush that has been molded by use rather than one that is brand new. I equate this to a rounded pencil-tip to get delicate shaded effect as to one that is freshly sharpened. Having said this, sables with a fine point are essential for details such as the eyes and the seam of the mouth.

Essentials for Sfumato

Time and an alert artist are crucial for a successful painting of the Mona Lisa. This project had been completed in 5 stages, which are:

- Stage 1: The underdrawing and the underglaze.
- Stage 2: The underpainting.
- Stage 3: The chief glaze.
- Stage 4: The dry brushing.
- Stage 5: The background.

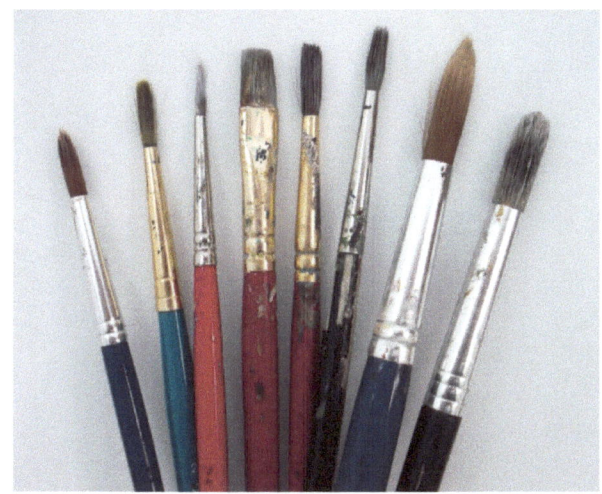

As can be seen in this picture, sables need not be in pristine condition to create soft, sfumato effects. In fact, used bristles are preferable.

These steps are explained fully as they occur. Stages 2 and 3 are the most intensive sessions of the five and require around 4 hours of painting time each on separate days. This will enable the artist to reap the advantages of oil paint, but also means planning ahead. Steps 1, 4 and 5 will take around 2-4 hours each, again on separate days. Of course, breaks should be incorporated when needed.

Painting the Mona Lisa: a Summary

Other books may explain different ways of achieving sfumato effects. In here, I have devised a technique by a combination of glazing, dry brushing and working the oil paint as it begins to oxidize.

Unlike waterbased paint, such as watercolour and acrylics, oils do not dry by evaporation, but as it oxidizes with the air. This means it thickens slowly, eventually forming a skin after a few days. Some pigments will thicken quicker than others; burnt umber is particularly quick to dry; alizarin crimson will thicken more slowly. I use this steady-thickening of the oil paint to achieve effective sfumato, which will be explained a little later in this book.

To add depth to colours, I conducted the shading over the face, not once, but several times. It is almost impossible to recreate Leonardo's depth of tone and smooth gradations in one go, as in alla prima. Further, as the background within the painting is blocked in, the overall tonal balance of the figure will appear to shift. This means making constant modifications over the facial features until the final session.

Preparing to Paint the Mona Lisa

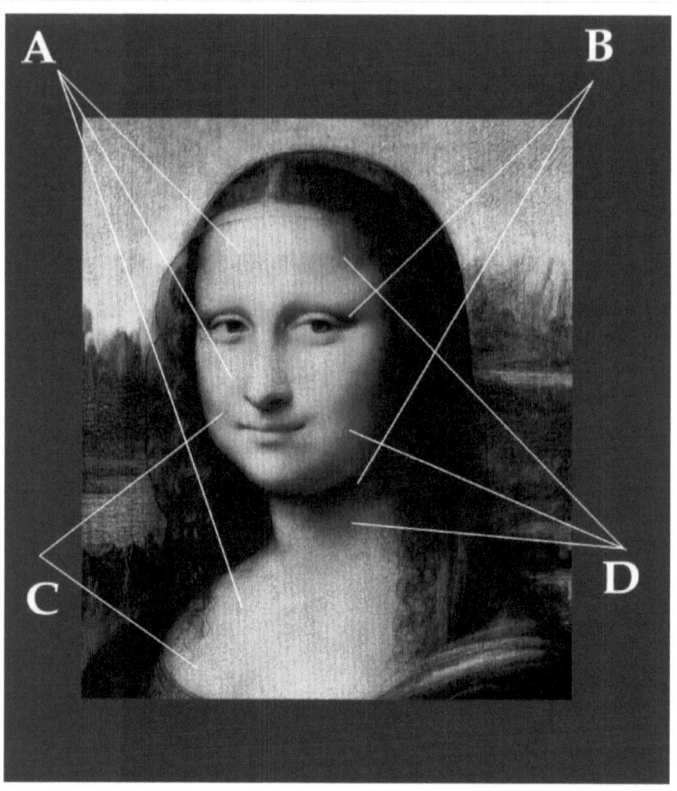

Tones of similar values can be seen running throughout the face. Here, these tonal values can be divided into roughly 4 areas, as can be seen in A, B, C and D.

The main challenge in painting the Mona Lisa is the shadows on the face. Ultimately, achieving great sfumato effects requires high awareness of tones. One way is sensitive understanding of how tones relate with one another. This means standing back from the painting from time to time and looking for an overall view.

Take a look at the image on the left (reproduced in black and white to prevent colours interfering with tonal values). Notice how similar tonal values can be seen running throughout the painting.

The tonal values denoted by A are roughly the same. These are all expressed as flat areas of highlight around the brow, cheekbone and chest.

B again shows the same tonal value, this time the darkest shadows on the face, being the underside of the chin and above the left eyelid. A and B therefore illustrate the palest and darkest areas of the face.

C and D show tones between these extremes. C is a step darker than A, denoting faint shadow beneath the cheekbone and just above the neckline. D is a step paler than B, illustrating the sides of the face and soft shadow around the neck.

Awareness of Tones in Painting

Of course, there are other, more subtle shadows beyond these four increments. The aim here is to be aware of how one tone relates with another throughout the face during the painting process. For instance, the shadows above the eyelids are surprisingly dark (almost as dark as the hair). The beginner may be tempted to take a diffident approach here and mix a more subtle colour because of where these shadows occur. This will result in an anemic, flat pallor to the portrait. Another thing to be aware of is incorrect tonal balances, that is, tones that do not relate to one another as shown in Leonardo's painting.

Now take a look at the images opposite which show the Mona Lisa under different tonal keys (or tonality).

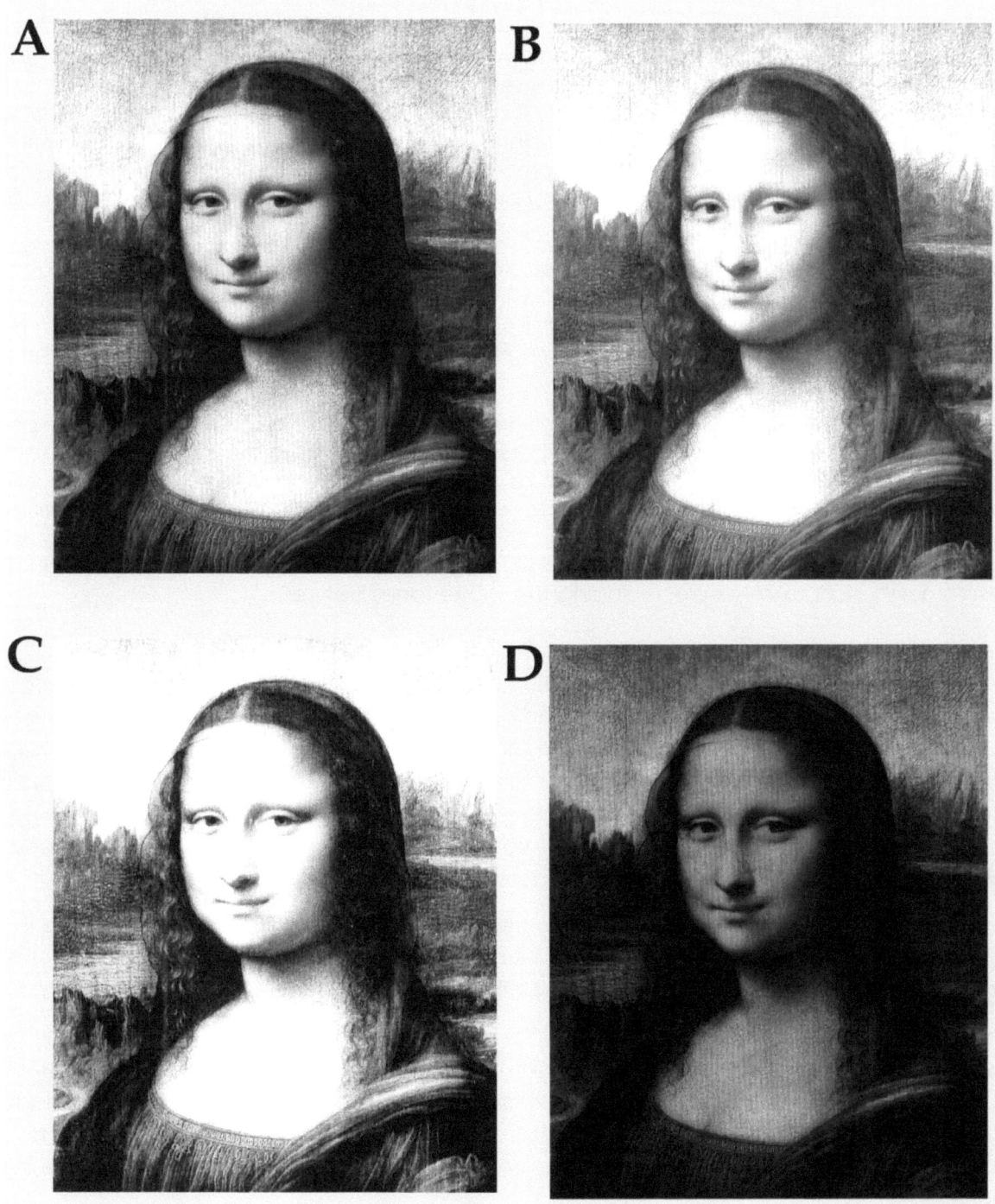

High versus Low Tonal Key

A tonal key is the overall tonal value of an image. A high tonal key is an image that has few darks and therefore is predominantly pale. This can be seen in an overexposed photograph, such as the image 'B'. Similarly, an image with low tonal key is an image that is predominantly dark, showing few highlights, as in an underexposed photograph. This can be seen in the image 'D'. The ideal is to include all tonal values within the painting from very dark to very pale. This might seem obvious, but can often be overlooked during the painting progress and I have seen many students struggle with sensitively depicting the tonal key in painting.

A common culprit to a painting with the incorrect tonality is expressing the darkest areas too pale first-off, such as the aforementioned eyelids. This will knock the rest of the painting off-kilter, resulting in a painting that appears pale overall. Painting straight onto a white art surface will give a misleading impression of a colour's tone, making it appear darker than it actually is, until the rest of the art surface has been painted in.

Another common problem is expressing tones as definable shapes, resulting in dark shadow-pools that fail to convince. This can happen when expressing tonal values too steeply, as can be seen in the image 'C'. This image has a high tonal contrast, meaning that tonal values veer steeply from pale to dark. Notice how the shadows appear to have shrunk, giving the face a flat appearance. Little middle-ground can be seen here. The artist should aim for a perfect balance of highlights and shadow and but also the tones between. The image 'A' is the ideal aim, which is to include all tones from very dark to very pale, including the subtle tones between.

When not to Express Lines

Resist the temptation to illustrate lines if none can be seen. Sfumato is all about light and shadow, not lines. Whilst painting these subtle shadows, squint the eyes to simplify the view. Sometimes high detail and colour can get in the way of seeing the painting truthfully as a whole and in a simplified way. Stand back from the painting now and again to get an overall impression. A shadow that appears dark close up may be indiscernible from afar. If something nags but won't reveal itself, view the painting through a mirror or turn it upside down. This will make the problem jump out.

Illustrating the shadows on the face may require much concentration, but it is worth bearing in mind, that only around 35% of the painting requires this skill. If the highlights and shadows on the face are effectively expressed, the rest of the painting is likely to fall into place.

Beware of idealizing the face. Don't paint 'eyes' or a 'nose' but a soupcon of shadows that come together to look like eyes or a nose. Take a look at the close up images opposite and you will see abstract areas of shadow. Features become less recognizable when the image is turned upside down or put on its side, as can be seen here. Before undertaking the painting, it might help to have a go at painting these small sections of the Mona Lisa, such as the edges of the eye or the underside of the nose.

More tips to help the artist when things don't go to plan can be found at the back of this book. And now to stage 1 of the painting: the underdrawing and underglaze.

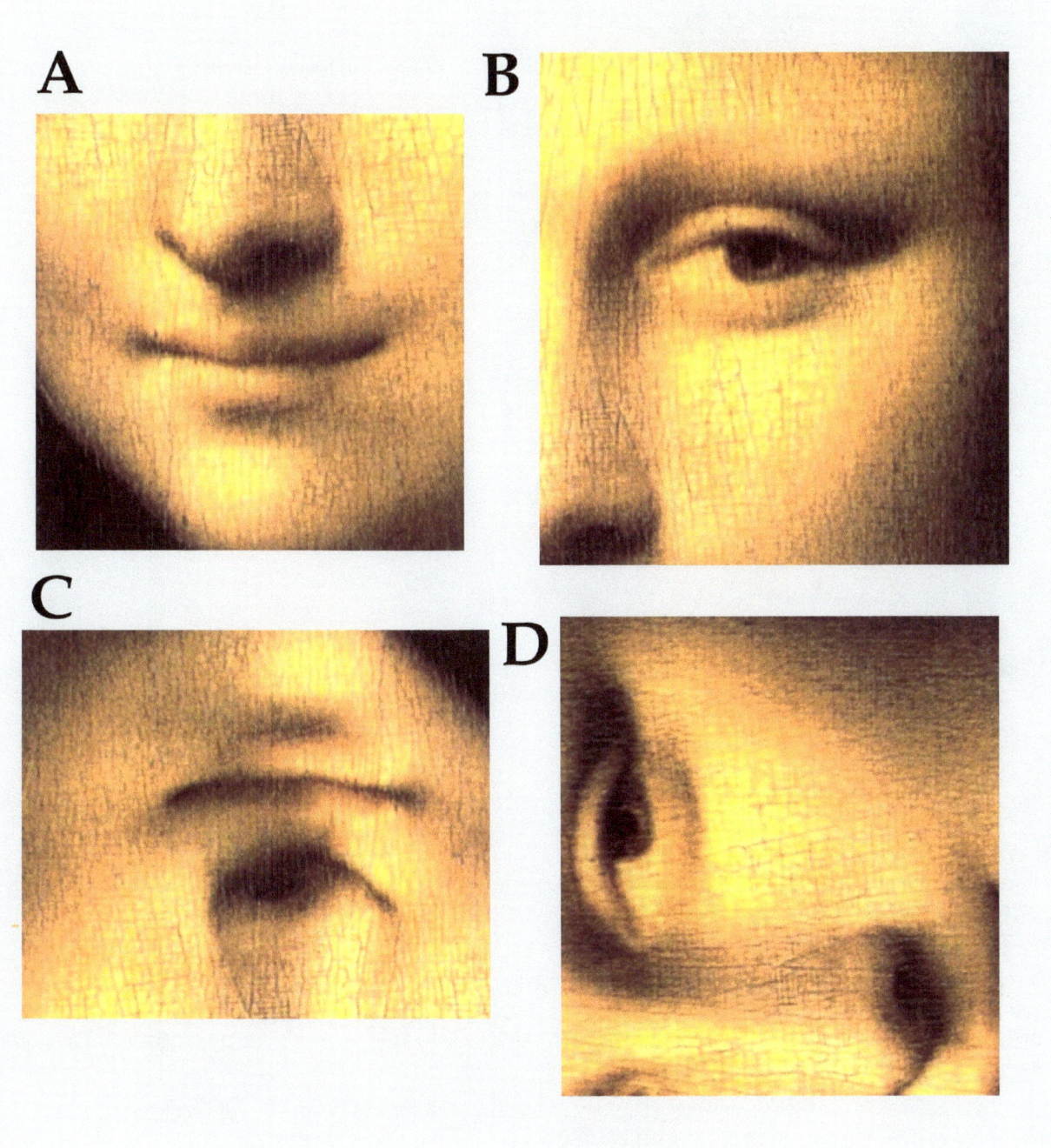

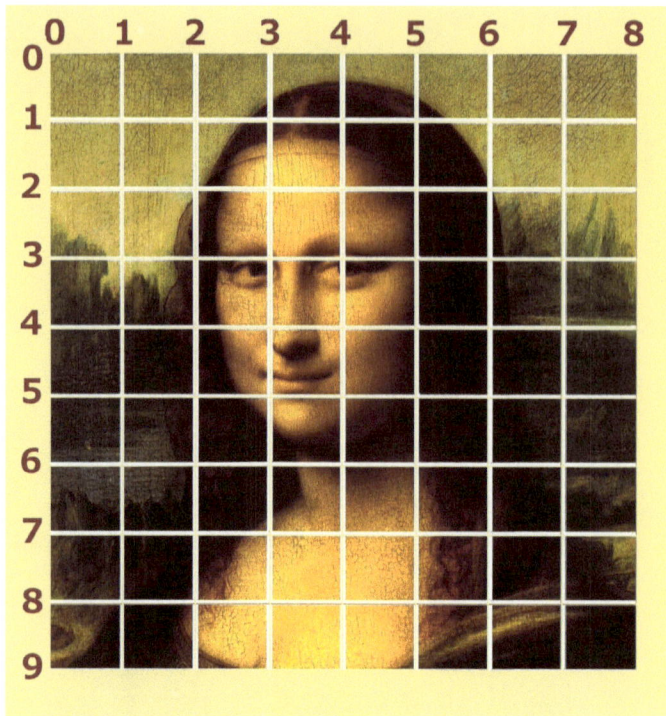

The grid method is a tried and tested method of scaling up or down an image

Stage 1: the Underdrawing and the Underglaze

Embarking a painting of the Mona Lisa may cause some consternation. How can the curve of the mouth or the shadows beneath the eyes be painted accurately? This is why preparation is vital to a successful portrait of a challenging subject. Thorough preparation will help prevent problems from developing later.

Some artists are sufficiently confident to lay the paint straight onto the art board without an underdrawing or an underglaze. But I would not recommend this for the beginner. An accurate drawing is important from the start, so I would reserve a separate day for the drawing alone.

There are various means of transferring a portrait onto the art surface. Freehand is ideal if possessing a natural flair for drawing. If doing so, work pale initially until assured of accuracy. Use a soft pencil throughout, viewing the image as an abstract series of lines and shapes, working from the large areas down to the small. Take extra care over plotting the facial features.

Drawing Methods

An enlarger adds convenience and speed, as the image is projected straight onto the art surface. Tracing the image is another method. Follow the lines faithfully on tracing paper. Place over a sheet of carbon paper and by pressing firmly via a sharp nib, the image will be transferred onto the art surface below.

If the image needs to be scaled up, the grid method can be useful. Draw a grid onto a piece of clear plastic. Number each line as shown. A fine felt-tip will make lines clear. Draw a corresponding grid of the required size in faint pencil onto the art surface and map the image carefully against each square.

If unsure about the accuracy of the drawing, stand back from it; turn it upside down or view through a mirror. This will reveal hidden issues.

If doubts remain, rub out the offending area or start afresh. There is nothing worse than a painting that inherits a problem from the drawing. Rub it out or the problem will continue to niggle throughout the painting process.

When Not to Believe in Lines

Some might argue that using a drawing aid is 'cheating.' Nothing could be further from the truth, particularly in the case of the Mona Lisa. Sfumato shadows refuse to be pinned down by lines. Simply applying paint over the drawing will not produce a portrait with truth or realism. A line can often betray. It may outline a highlight to a cheekbone or a shadow on the temple. Too much faith in the underdrawing will result in an inaccurate portrait. The nature of this portrait painting, I believe is 5% linear and 95% shades/colours.

I periodically check for accuracy of the portrait painting against the photograph, modifying upon the underdrawing. Painting is really the process of applying colour shapes on top of the drawing which informs on colour and tone. The drawing is merely a preliminary guide.

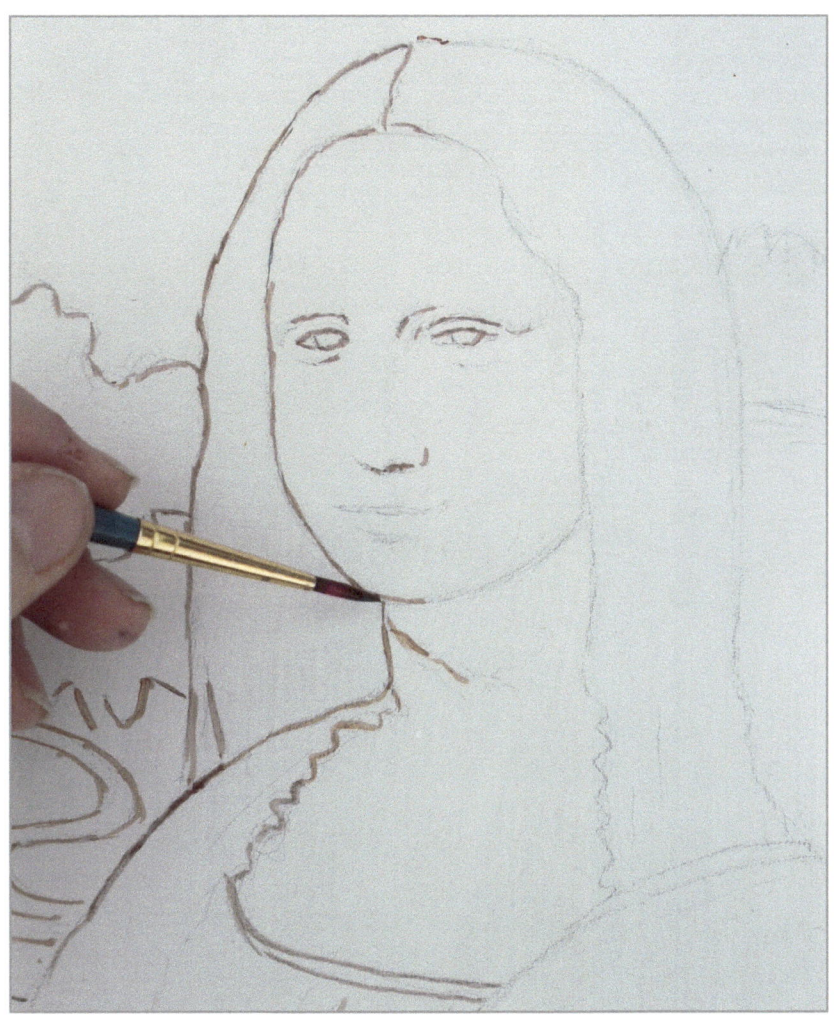

Applying the Imprimatura

Once the portrait has been accurately sketched, the underglaze (sometimes known as the imprimatura) can be applied on top. The underglaze can be diluted oil paint, but I used diluted acrylic paint as it is waterbased and dries water-resistant. The purpose of the underglaze is to rid the whiteness of the art surface, making tonal value of colours easier to discern; applying highlight colours onto a white artboard would be like trying to see the shape of a snowflake against a white background. Only when viewed against a definite tone will its shape become obvious. The underglaze therefore provides a mid-tone from which other tones can be judged – a vital component for sfumato technique.

Applying the underglaze is explained a little more in the next chapter where we embark the underpainting, the second stage of this demonstration.

Stage 2: The Underpainting

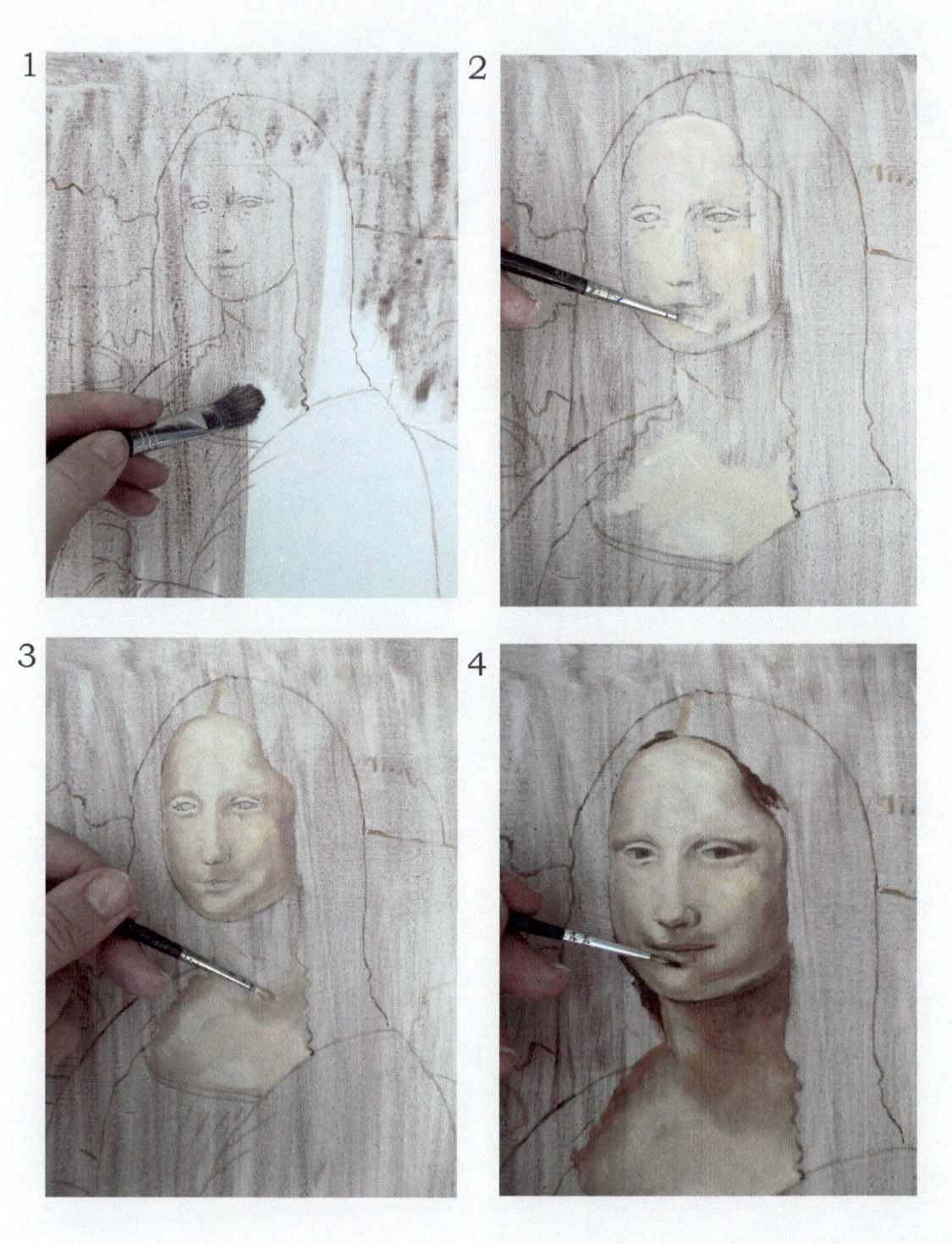

The Foundations of Painting

1 The project begins with the underdrawing as discussed in the previous chapter. The drawing had been completed on a separate day to the painting. I overlaid the lines with burnt umber acrylic paint from a fine sable so that the drawing will still be visible beneath the imprimatura.

The imprimatura was prepared with half-a-cup of water mixed with 2 cherry-sized blobs of burnt umber (or similar brown) acrylic paint. Mix the paint into a small amount of water initially, to rid the mixture of any grittiness before adding more water. Aim for a runny glaze. Once mixed well, I applied the glaze to the art board, using broad, sweeping strokes via a wide bristle. Aim for an even, translucent coat. If the imprimatura turns out too pale, allow to dry and apply another coat. Each coat will darken the glaze further. Aim for a mid-brown colour.

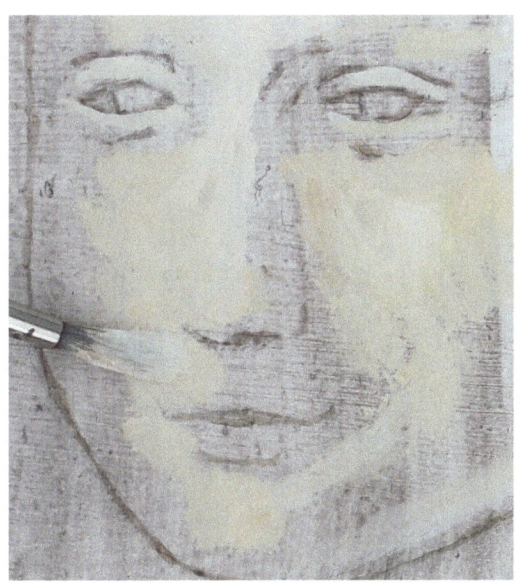

Keying in Tones

2 Once the underglaze was dry, I embarked upon the underpainting. This first layer of oil paint will lay the foundation for subsequent glazes, increasing depth of colours and smoothness to blends.

I worked on the highlights first as I am then able to key this colour into the shadowed areas to be applied subsequently. With a fine sable, I mixed a little burnt sienna into white. I then added a tiny dab of cadmium yellow. This resulted in a golden hue. I lightly applied this colour onto the flat planes of the face such as the cheeks, brow and chin. I worked the paint progressively thinly towards the edge of these highlights without adding any oil medium. This thinner paint will permit smooth blending with the neighbouring darker colours. A fine sable was used throughout.

3 I introduced a little burnt umber into the pale colour mix and worked around the edges of the pale shades applied in step 2, working outwards towards the hairline and the neckline.

Be careful not to go over any areas where deep shadow will be applied, or the pale colour will be picked in the dark mix. Again, the paint layer was made progressively sparse towards the edges of shadow where these darker areas will be expressed. I wiped excess paint onto a rag to retain paint control. I used this mid-brown colour for the whites of the eyes and around the eyelids.

4 I find sfumato is best achieved with a dry consistency to the oil paint. I therefore dried the brush between colour mixing. I blended burnt umber with a dab of pthalo blue and this time worked on the areas reserved for dark paint, working back from the edges of the face. I lightly mapped this dark colour over the hairline and under the chin. I could instantly key in the shadows shapes against the underglaze. I knitted together these areas of shadow into the middle tones described in the previous step. Notice the darkest areas of the face are the eyes, the underside of the chin, the seam of the mouth, above the eyelids and beneath the nose. I wiped excess paint from the brush and blended this dark colour into the neighbouring pale colour to a smooth blend. Take extra care with the seam of the mouth and detail around the nose and mouth.

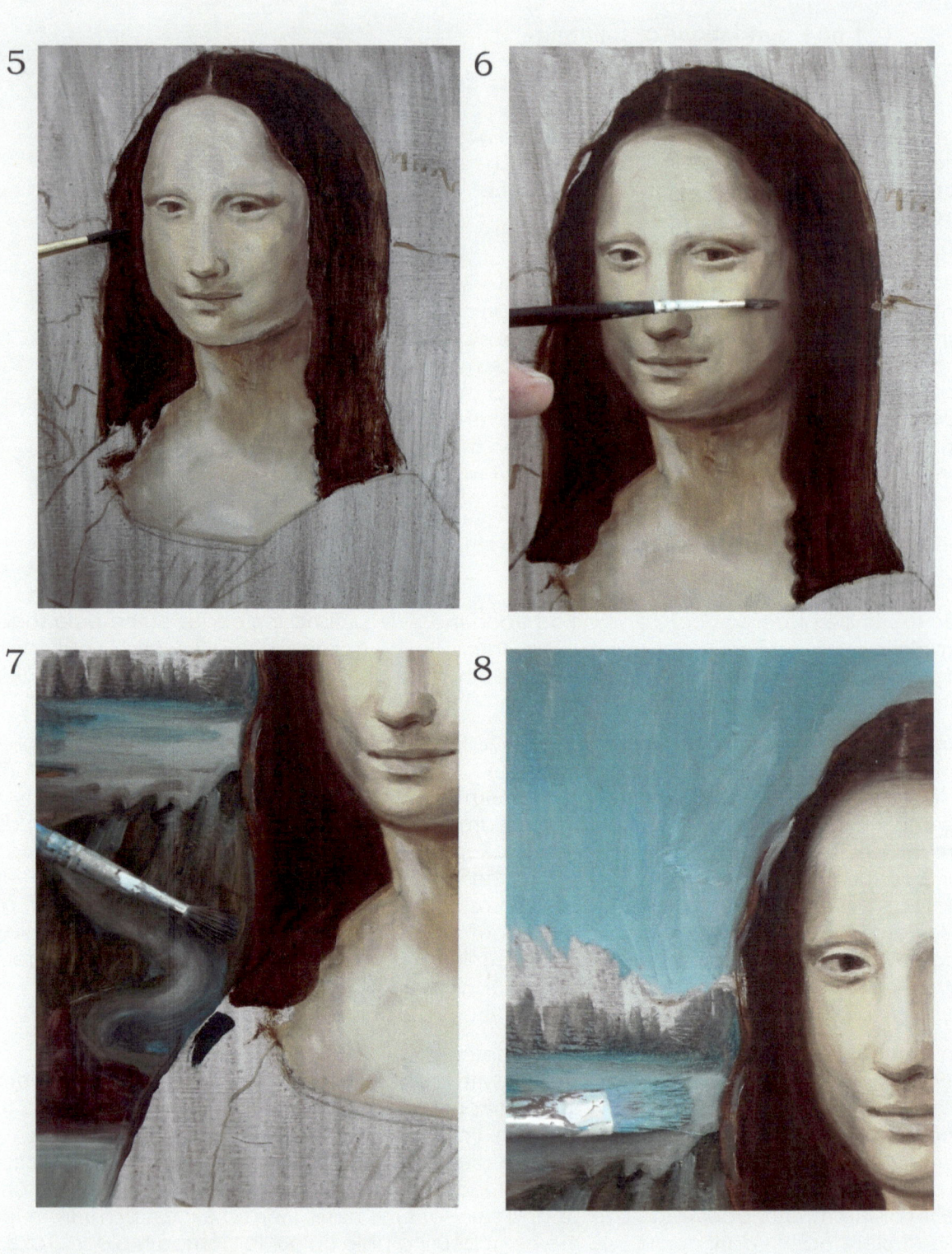

Altered Tonal Values

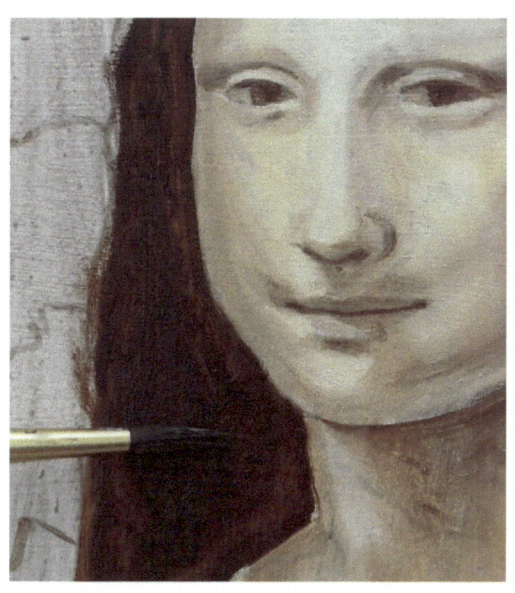

5 This picture demonstrates how apparently dark tones can suddenly appear bleached out alongside much deeper tones. This is what happened when the hair colour was applied around the face. Although accuracy is vital here, don't worry if the shadows are not spot-on at this stage. The subsequent glaze will offer the chance of increased accuracy regarding tonal value and shape.

With a medium sable, I pasted on the hair colour with burnt umber and a little pthalo blue. The hair provides a frame to the face which will make shadow-shapes easier to pin down. Necessary adjustments to the facial features are inevitable. I worked the brush into the direction of hair growth from the crown downwards.

6 I wiped excess paint from the brush, but reserving residue of the dark hair colour and reinforced the shadows around the cheekbones, beneath the chin, the nose and eye sockets. I dragged the dark colour from the hair over the sides of the face with the aim of softening the boundary between the hair and face colour to suggest form. This will help the sfumato effects later.

Notice reflected light beneath the jaw. Take care not to apply dark paint over this area or this subtle detail will be lost. Eradicate harsh lines from the edges of the face with a clean, soft sable. The best effect will be achieved in one sitting, whilst the paint is workable. Burnt umber will thicken somewhat after a few hours of painting. A little linseed oil can be applied onto the mixing palette to help it flow.

Unused Muted Colours

7 Only once happy with the blending of this first paint glaze on the face will I move onto the background. Here is a chance to take a break or continue on another day.

With a medium bristle, I mixed a little alizarin crimson with pthalo blue and a little burnt umber, then worked this murky colour around the darkest areas of landscape such as the canyons. Additional alizarin crimson was applied further down.

Unused colours on the palette such as cadmium yellow have been incorporated into some of the landscape colours. This resulted in pleasing muted greens. For the lake, I added a little of this colour into white and pthalo blue. The water's surface was suggested with horizontal strokes.

8 With a wide bristle, I mixed additional pthalo blue and white into the aforementioned muted colour and pasted it across the sky. I introduced more white towards the horizon. This same pale turquoise colour was added to the lake on the right and the misty canyons in the distance to offer some continuity to the landscape colours. This would help unify the landscape behind the figure. I used this same muted blue colour to soften the detail of the dark canyons to eradicate jarring harsh lines. At this stage, I used a loose approach, aiming to cover large areas of the background with bold strokes.

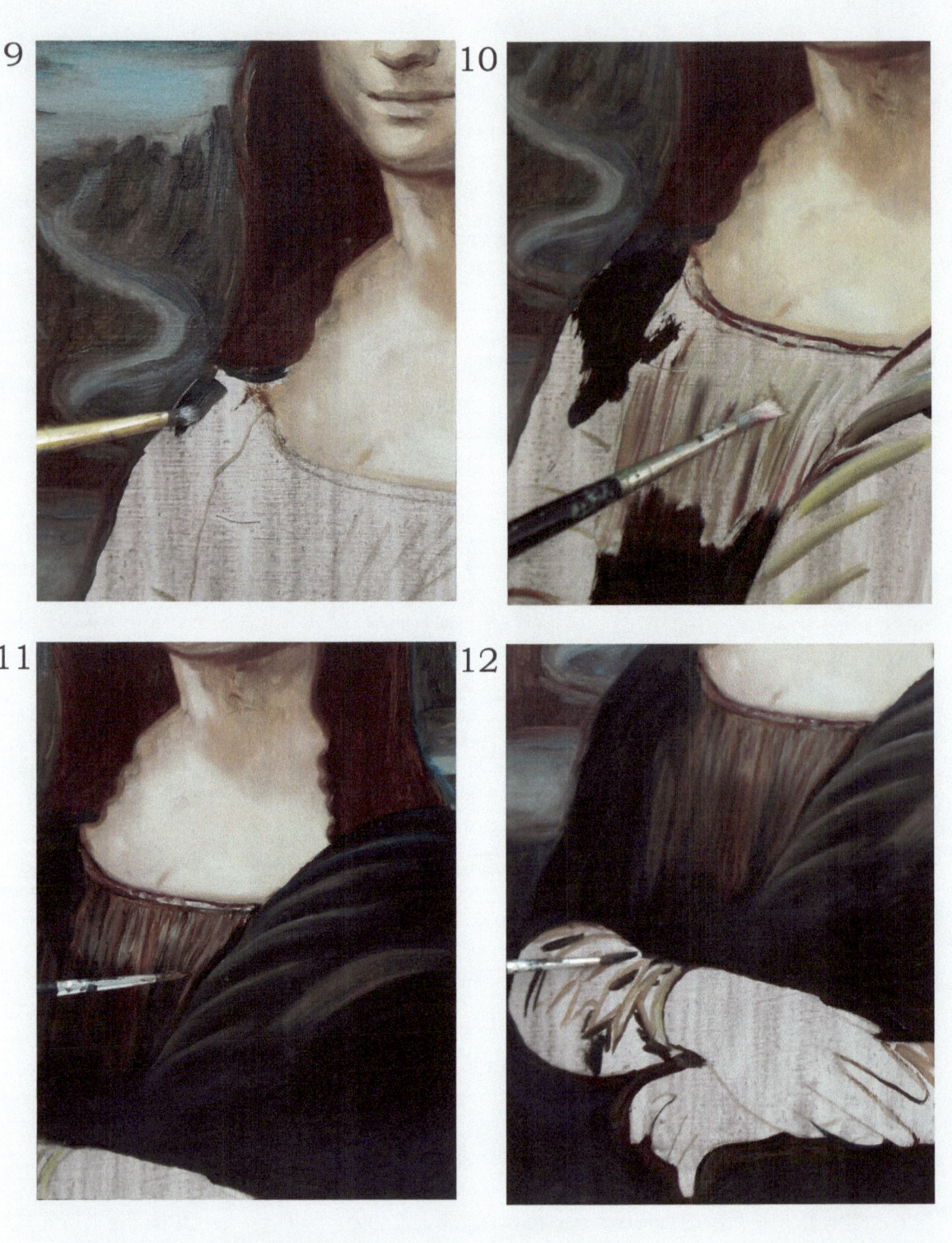

Blending the Background

9 With the medium bristle, I worked further down the board, expressing the darkest colours at the foot of the painting. This difference between the heavy colours and the mist reinforces the sense of depth. Be careful not to blend out the canyon crags or the rocks will appear featureless. A harsh bristle was ideal for expressing these perpendicular features. Whilst the paint was still wet, I blended the background colours to soften some of the brush marks. This was important for the lake and the winding river. Although no black was used in this painting, a near-black is possible by the mixture of cadmium yellow, pthalo blue and burnt umber. This rich colour was used to add definition to parts of the landscape in the foreground.

Suggesting Detail

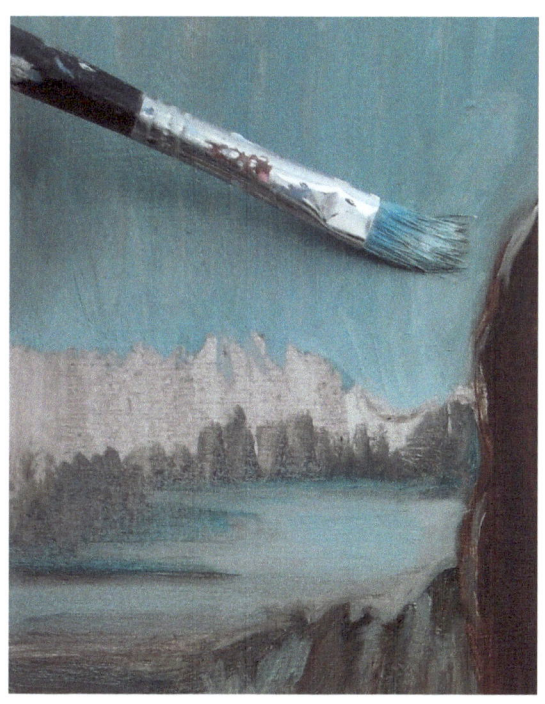

10 With a fine sable, I softly blended the outlines of the figure into the background to eliminate the impression the Mona Lisa had been cut out and stuck on. I then began on the garment. With a medium sable, I illustrated the rolls of fabric on the collar area with burnt umber, a little pthalo blue and white. I then added a little burnt sienna to the pale colour to express the intricate folds on the chemise with even, downward strokes. I made preliminary dark marks nearby with a separate medium sable, to ensure the darks and pales possess the correct tonal relationship. Burnt umber and a little pthalo blue were used for these shadowy areas of the garment.

11 I continued blocking in the dark colours over the garment, dragging the paint almost to the highlights, but not too close, or this dark colour will overwhelm the pales. A little alizarin crimson was added to inject warmth into these highlights.

With a clean, fine sable, I softly blended the two tonal areas, working outwards from the pales and into the darks. I moved the brush into the direction of the folds via vertical strokes. I softened harsh tonal divisions in order to convey the softness of the fabric. I wiped excess paint from the brush and softened the outline between the neck and the garment. A steady hand is needed here.

12 I worked in a similar fashion over the sleeves, applying burnt sienna and white to the highlighted folds. Notice the zigzag formations here, which can be simplified by viewing these creases as an overall pattern. I worked progressively darker by adding burnt umber and pthalo blue to the colour mixture and applied this colour onto the neighbouring areas of the sleeves. As before, I pulled this dark colour up to the highlights, blending where the two meet. Wiping excess paint from the brush prevents the dark colour from overpowering the pales. If this happens, the dark colour can be wiped off with a rag and pale colours reapplied.

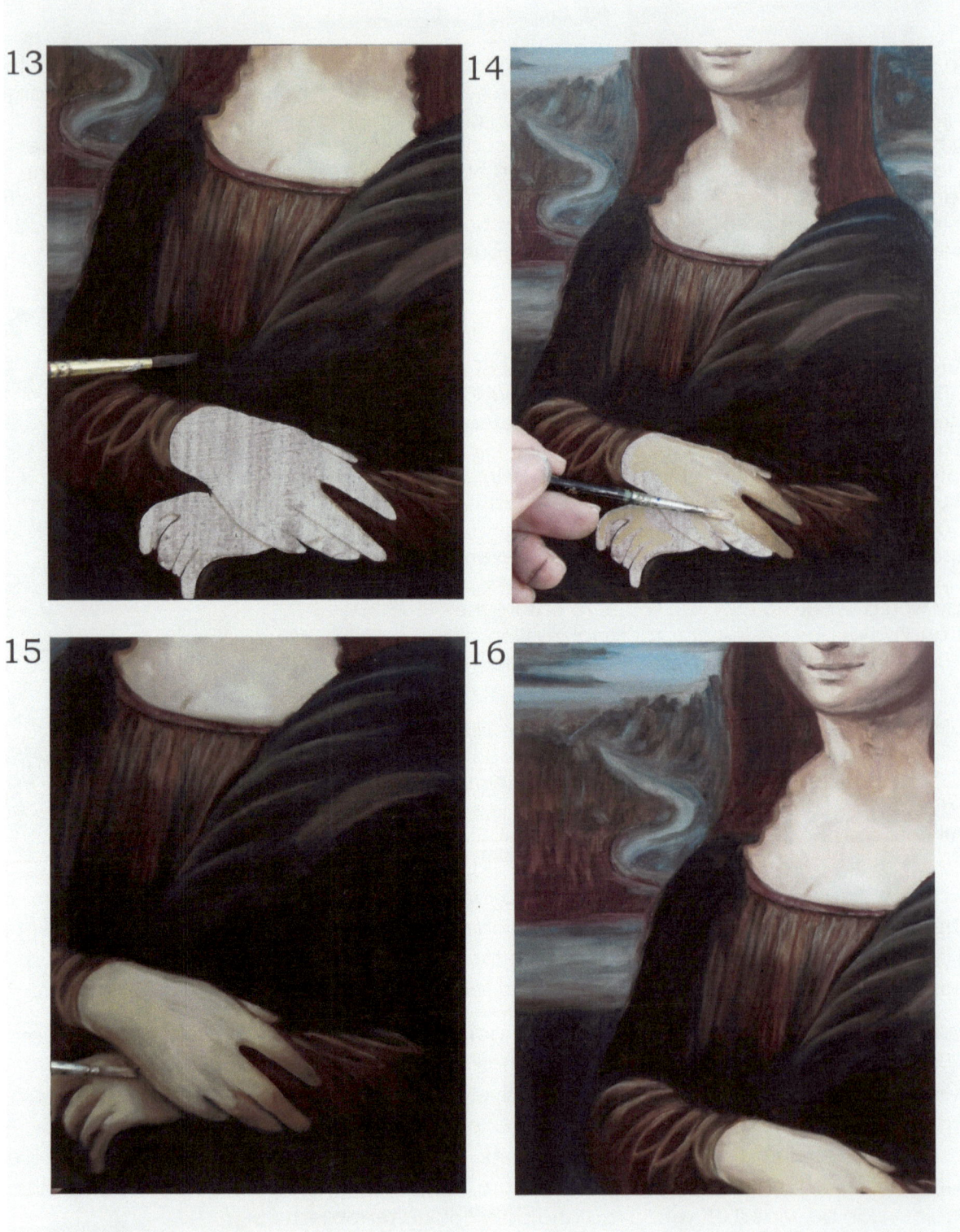

Painting the Hands

13 I worked over the garment once more, eradicating harsh brush marks and steep tonal gradations which could draw the eye unintentionally. Always complete blending tasks in one go whilst the paint is workable, otherwise, the paint layer will have to be worked anew as a completely separate glaze. I softened the outlines of the garment against the background so that they appear almost as one on the darkest areas. Notice how the outer garment is slightly bluer in hue than the inner garment which contains more burnt sienna; the outer garment contains a higher mix of pthalo blue.

14 I worked on the hands next, checking the colour mix has some parity with the face. With a clean, fine sable, I mixed burnt sienna, a little cadmium yellow and white and dabbed this creamy golden colour onto the backs

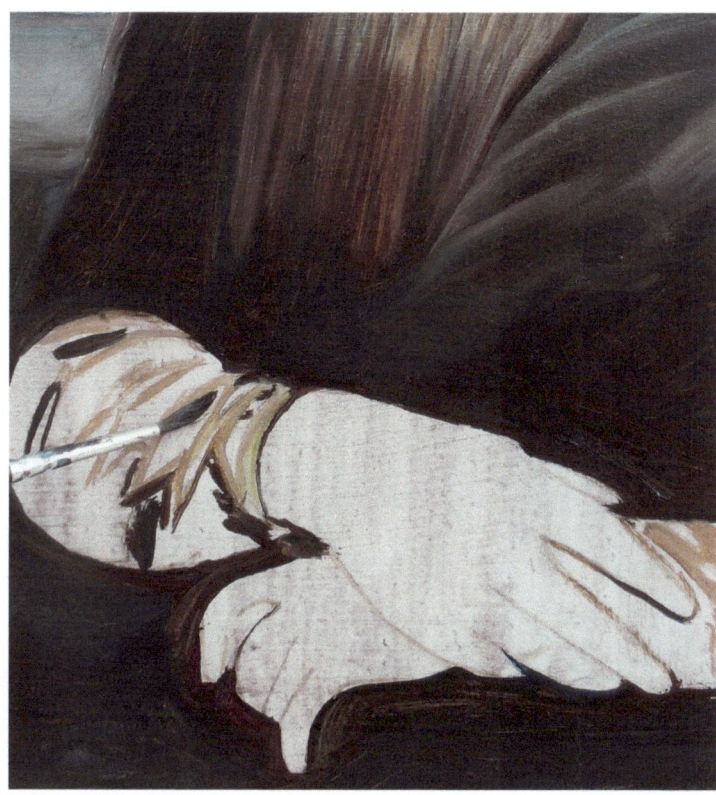

of the hands and knuckles. I added progressively more burnt umber for the shadow areas around the fingertips and the thumb. I also traced this incremental colour between the hand and the garment, so that the hands do not appear as flat areas. Notice how the highlights on the sleeve and the hands are similar in colour, creating a chromatic echo in the painting.

Blending Hands into the Background

15 To suggest shadow falling over the left hand, I added burnt umber and a little pthalo blue to the initial hand colour and applied it to the backs of the knuckles.

I blended this dark colour outwards so that it eventually dispersed into the pervading paler colour. I eliminated outlines to the hands by blending the surrounding garment colour into the hand colour. This will imply form to the hands and make them appear to belong to the surroundings. Line elimination is the feature of this painting and will help sfumato effects to be applied later.

16 Before putting the painting away for the chief glaze, I worked over the painting once more, blending out harsh brush marks and lines that could counter the sfumato effects sought after. Such imperfections will not always become apparent until the final stage of the underpainting.

With a clean, wide sable I smoothed over the sky and background, working downwards over the painting. With a separate wide sable, I blended over the garment and the hair, but decided to leave the face for the next glaze.

With the art surface covered with the underpainting, I decided to put the painting away for around a week, or until the paint layer is dry to the touch.

Stage 3: The Chief Glaze

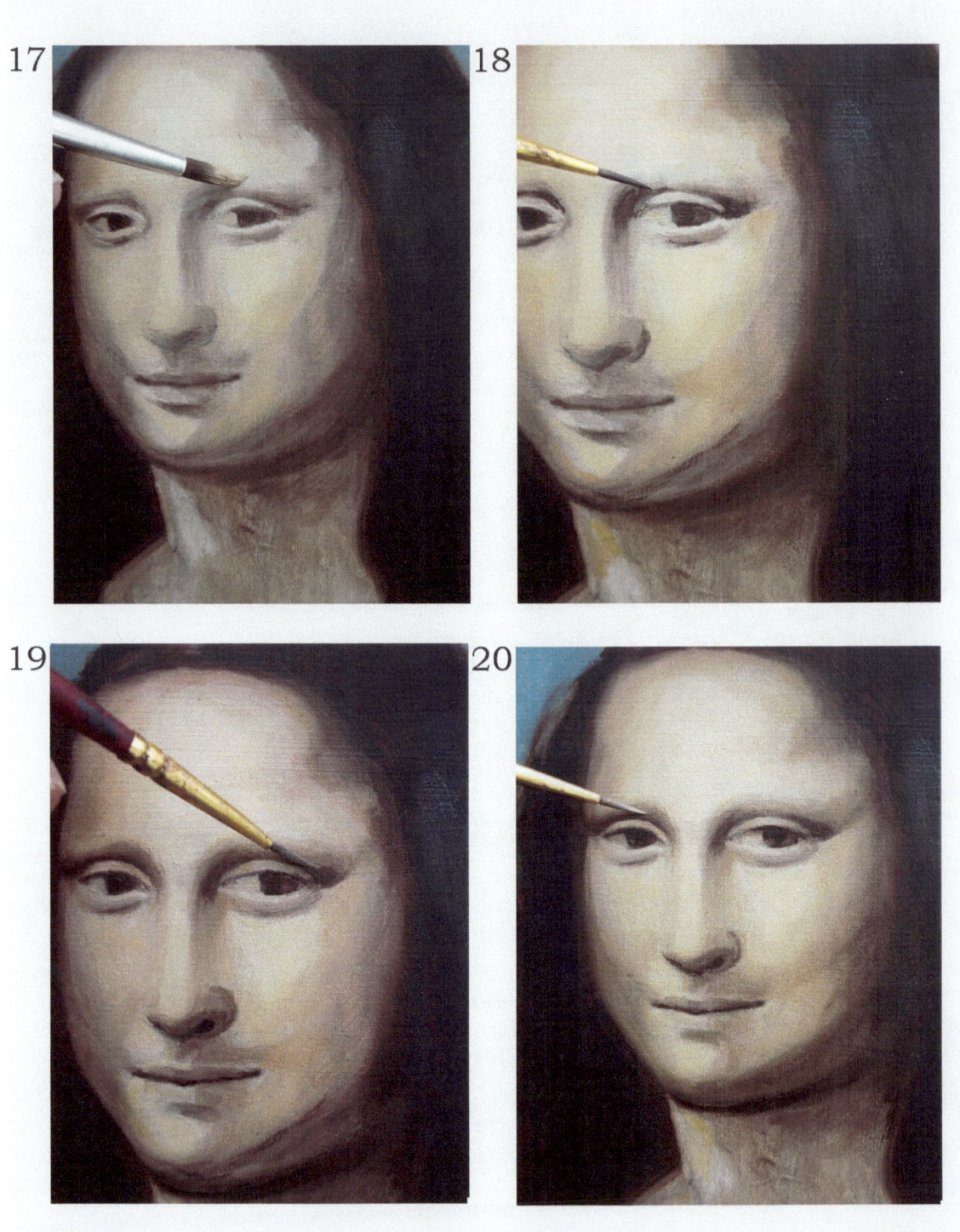

Oxidization of Oil Paint

17 The chief glaze has more significance than the underpainting in that it reinforces detail and colour blends previously conducted. For this reason, it is advisable to set apart at least four hours of painting time whilst the oil paint is still workable.

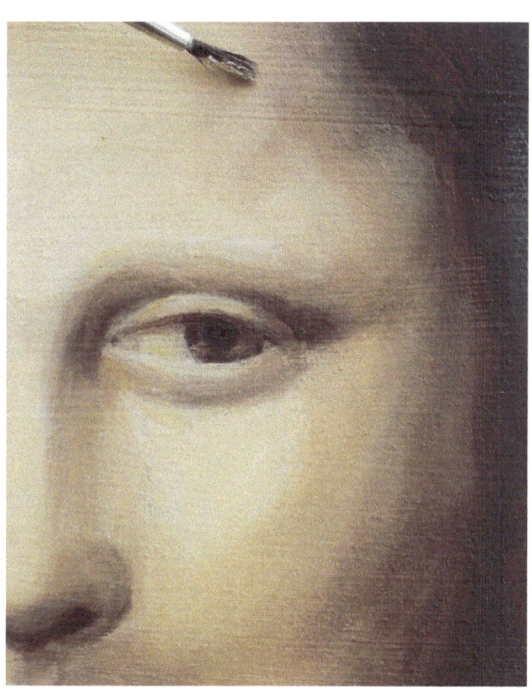

As mentioned in the section, 'What is Sfumato?' oil paint dries steadily by oxidization once exposed to the air, which means that it thickens over a number of hours. This property is a great advantage for sfumato techniques, as creating smooth blends becomes progressively easier as the paint thickens slightly. However, once the paint is dry, it can no longer be worked upon. I began this session by mixing a little cadmium yellow and burnt sienna into white. I applied this pale colour onto the palest areas of the face. Notice how the underpainting supports the chief glaze in that each brush mark has more impact. Don't simply apply the same colours and in the same manner as the underpainting, but modify upon it. Keep checking the painting against the reference material to ensure the colours are the right mix.

18 A little additional burnt sienna and burnt umber was introduced to the initial colour and placed over the fringes of these highlights, such as the cheekbone and edges of the brows. I left the darkest areas of the face untouched for now. With a clean, fine sable, I dabbed burnt umber over the upper eyelids, the bridge of the nose and the lower eyelids. Be careful not to go over the lower rims which should be pale in colour. I moved the paint brush lightly in the direction of the shadows to prevent them appearing heavy. I also used this colour to illustrate the eyes themselves. Be aware of how much of the pupil and iris are visible beneath the eyelids. Getting it wrong will cause an unintended expression.

Blending out Existing Colours

19 I cleaned the brush and then blended the dark colour into the neighbouring pales. I did not add any colour, but blended out existing colours on the art surface. Notice the smooth gradations over the upper and lower eyelids. I used this same approach for the shadow beneath the nose, mouth and chin. Take extra care over the shape of the shadows and the degree to which they fade into the pervading pale colour. These shifts are steeper in some areas than others. Once satisfied with these preliminary blends, I reinforced dark areas, such as the seam of the mouth, nostrils and chin.

20 With the sable used in the previous step, I mixed a little burnt sienna and burnt umber into white and blended this light-sepia colour over the cheekbone and jaw, to form the incremental colour between pale and dark. Notice the faint contours joining the left eye to the temple, and also the corner of the lip to the ear area. With the same brush, I blended out the tones above the eyelids once more and reinforced the outlines to the eyes. As will be seen, it is often necessary to work over the same areas several times to achieve high blends as the oil slowly oxidizes.

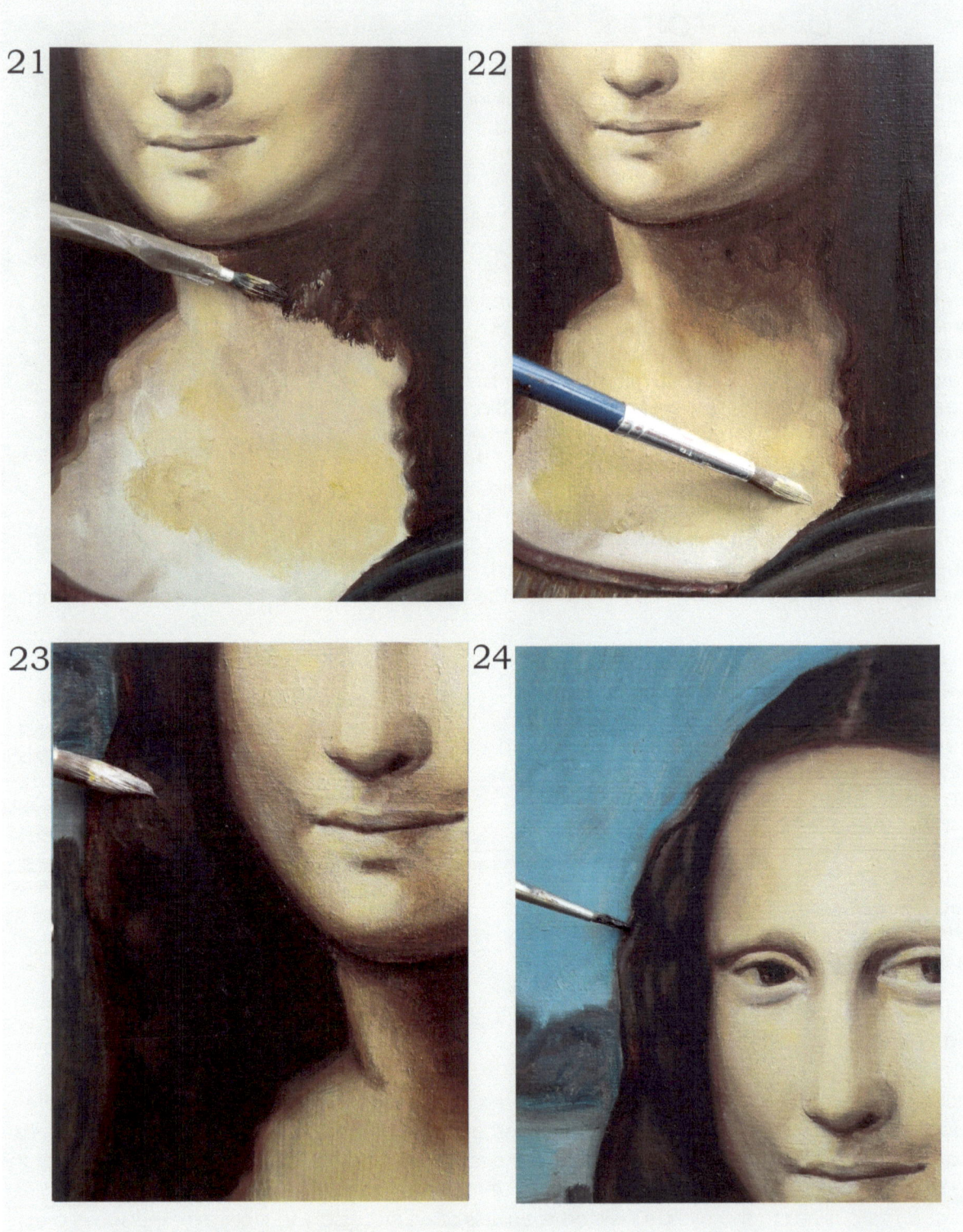

Fine Blending

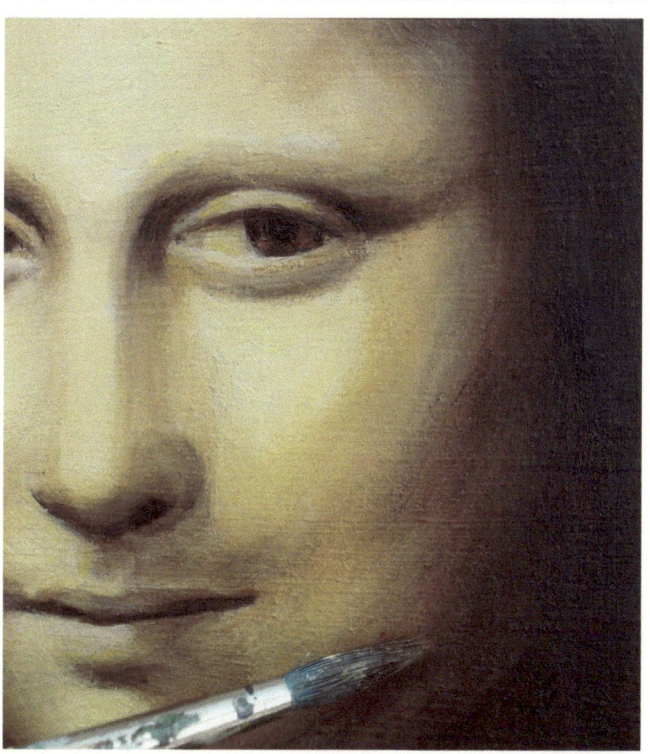

21 I deliberated over the blends of the face, refining and modifying. The more I worked over the area, the more shadow-shapes I noticed. Ensure every one is illustrated. Notice the faint shadow running horizontally from a point between the nose and mouth; the right cheek exhibits a triangular-shaped shadow running from the corner of the mouth. Notice also the faint shadow running down the side of the nose. Conversely, notice odd highlight shapes, like the small one on the left corner of the lips.

Constant blending was required for each area. I employed two sables simultaneously, one for darks, the other for pales. By this time, I had been painting for over an hour and had noticed the slight thickening of the oil paint. This is an important part of getting good sfumato effects. Once I was happy with the blends over the face, I worked down the neckline. I mixed a little cadmium yellow into burnt umber and brought this deep shadow down towards the neck.

22 With a separate clean sable, I mixed white into a little cadmium yellow and burnt sienna and pasted this colour over the pales on the neck. Notice the increased richness to this colour when applied over the underpainting. I added a little burnt sienna where the pale colour meets the dark shadow over the throat and softened the blend. I allowed some of the brush marks over this area to remain so that it doesn't end up looking flat. For this, I used soft, circular strokes. I blended the outlines of the hair to the neck to suggest fine strands.

Hair and Face Relationship

23 Successful rendering of hair results in treating it as an extension to the face. Rather than treat it as a separate subject matter, relate the colour of the hair to the neighbouring skin tones. I wiped surplus paint from the brush, and softened the seams between the hairline and the brow (see image 24). This helps suggest fine hair growing out of the scalp as opposed to a wig.

Notice shadows around the temples which are surprisingly dark and appear to vanish into the hair (see main image). Don't worry if the blends are not perfect, they can be improved upon in the next stage: the dry brushing. I proceeded to work the chief glaze over the hair with burnt umber and a little pthalo blue.

24 With the shadows illustrated over the face, I worked a little detail over the hair. With a medium sable, I dabbed a little burnt sienna and white over select areas of the hair strands. With a clean sable, I blended the edges of these ripples in the hair to make them appear soft. I reinforced dark areas to the hair to regain tonal balance.

Painting in the hair often means redressing the tones on the face. Now is the time to redress the overall tonal balance of the facial contours, as discussed in the section, 'Preparing to paint the Mona Lisa.' The aim is to include all tonal values from very dark to very pale, including all the subtle tones between. Ensure that no area on the face appear too pale or featureless in relation to the hair.

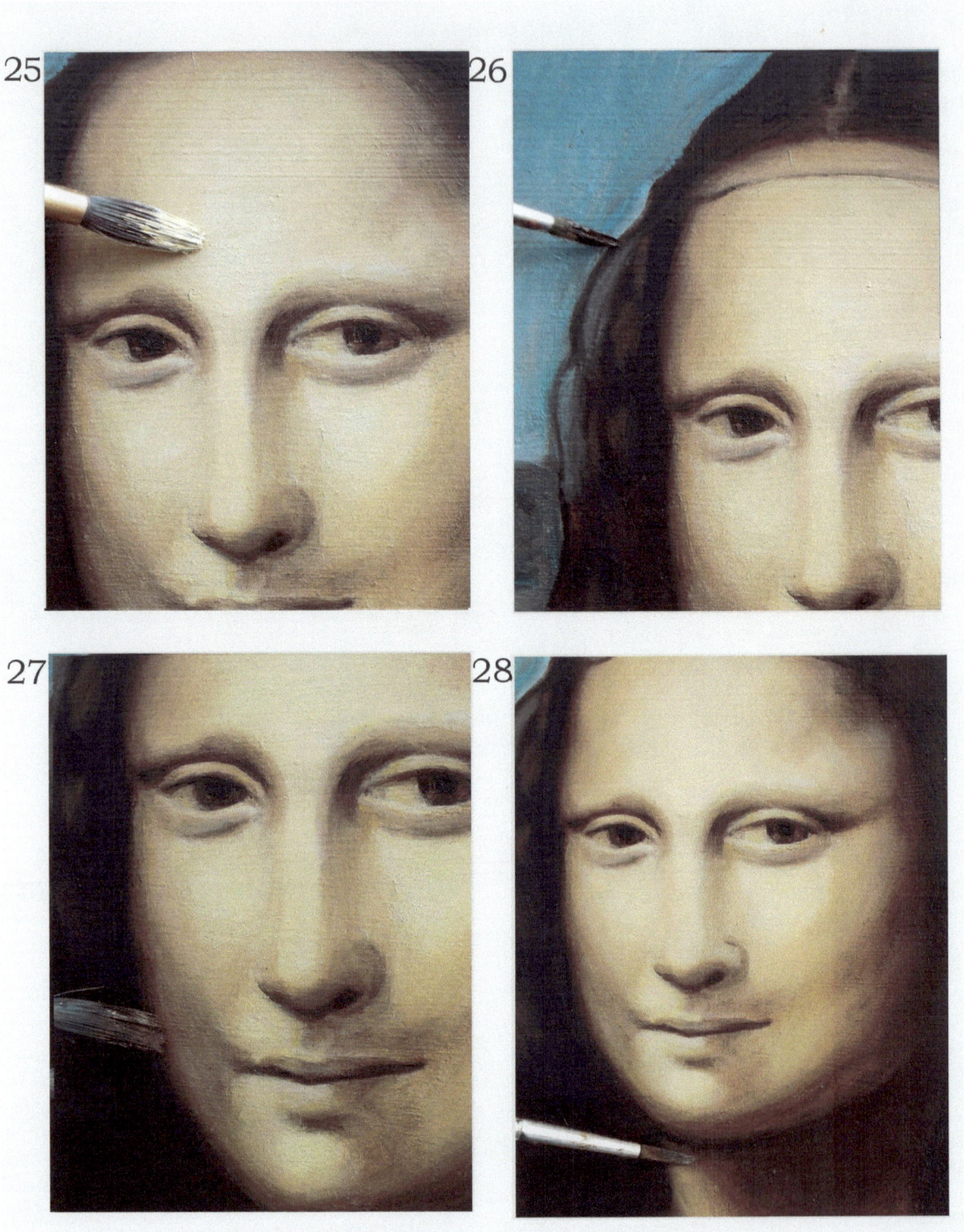

Applying Thickening Oil Paint

25 After working on the hair, I worked over the face again. As the oil paint had thickened further, I was able to work on top without too much of the paint mixing into this upper layer, even though it was still not dry. As the oil paint had been sitting on the mixing palette, exposed to the air for some hours, had become 'cakey' in consistency. This is ideal for dabbing highlights to the face.

With the 'pale' sable used earlier, I added more white to the bristles, mixing in a tiny dab of cadmium yellow and burnt sienna, so that the paint is almost white. I dabbed this pale creamy colour over the areas of the face to reinforce highlights. Attaining such richness on highlights could only have been possible after working over the painting several times. A tiny dab of this colour has huge significance upon the painting, so care is needed not to overdo it. I applied the paint over the brow, the bridge of the nose, cheekbones and chin.

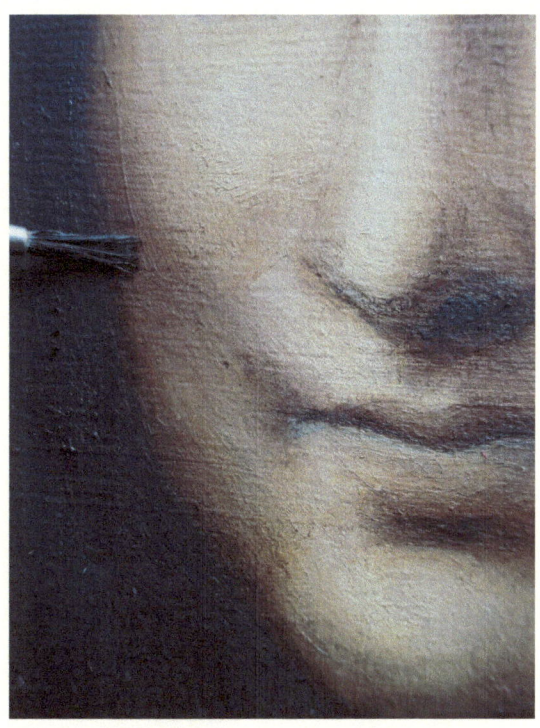

26 I smoothed out the edges of these new highlights into the surrounding colour to help support sfumato effects in the following stages of this painting. Once fully blended, I illustrated the dark piping of the headdress. I moved a fine sable, carrying a little burnt umber across the upper brow.

I moved the brush two or three times, smoothing out harshness to the line as I went. I darkened the skin colour just above this piping to suggest fine netting. I then added a little white to the midsection to suggest a contour to the veil.

Fine Tuning Blends

27 As the painting progresses, small niggles may present themselves that hadn't been visible before. The bridge of the nose and the contours of the mouth needed fine-tuning. With a dry brush holding very little paint, I lightly dabbed a little burnt umber around the mouth area, elaborating upon some of the shadows just above the mouth. I then lightly dabbed this colour over the right cheek, which suggests a slight smile.

The trickiest area of the painting I feel, is the angle of the nose and the dimple in the corner of the mouth. Ample time in getting this right will be worth it. Don't move on until satisfied with these difficult areas or it will have to be worked over as a fresh glaze. I lightly applied a little burnt umber to these areas to modify and deepen the tones.

28 I continued to reinforce the dark areas of the face with a soft sable, lightly drawing burnt umber beneath the jawline and down the right side of the face. These dark areas will be worked over with dry brushing in the next stage. With a fine sable, I had also made corrections to the nose, altering the shape of the nostrils slightly and the angle of the nub. At this stage of the painting, even a slight error will stand out. Stand back from the painting to ensure the shadows are the correct shapes. A faint shadow could look too dark or not dark enough from afar. Turning the painting upside down or on its side will help reveal problems that may not always be apparent.

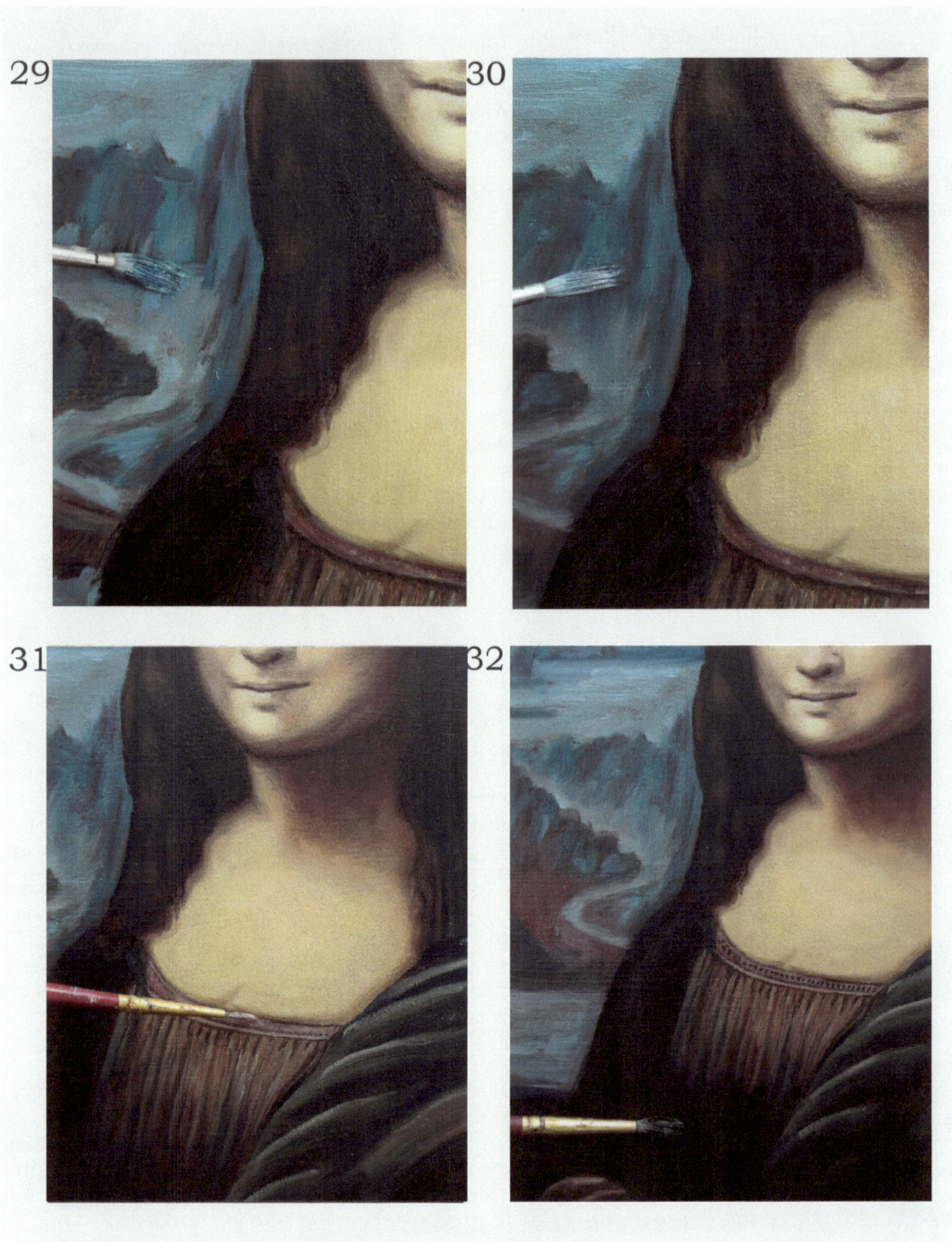

Elaborating on the Background

29 Now is a good time to take a break or leave the painting for another day before working on the background and the garment. This second glaze on the landscape gives the artist the chance to make modifications to the underpainting in similar fashion to the face.

I began with the mid-blues. I mixed pthalo blue into plenty of white and then introduced a little burnt umber and alizarin crimson to kill the blue's purity and expressed the crags on the canyons. I allowed colour streaks to remain, which result from picking up undermixed colours on the palette. Notice the difference in technique here, which is looser and more expressive than the technique used on the face. The lake and the sky contain more pthalo blue and white than the crag colours.

30 I wiped excess paint from the brush and carefully blended out some of the colour shifts. I added a little more white as I worked down the crags towards the river. As I worked further down the background, I used progressively more alizarin crimson and finally burnt umber at the very bottom where little detail can be seen. In the ensuing images, notice how this deep colour merges into the outlines of the figure. This approach will support sfumato, which is all about soft shifts in tone. I stood back periodically to ensure no part of the landscape appeared too heavy or too wishy-washy in relation to the figure.

Adding Detail to the Garment

31 Once satisfied, I embarked upon the garment. With a fine sable, I dabbed a little white mixed with burnt sienna and alizarin crimson and drew the detail around the neckline of the chemise.

I haven't copied the pattern faithfully, but suggested detail through small strokes. I moved the paint across the neckline to suggest the piping, and then I added burnt sienna to the brush and moved the paint in downward strokes for the highlights to the garment. Some blending is necessary here, but don't worry if imperfections persist for these can be put right in the next step. I added a little pthalo blue as I worked further down into shadow.

32 I mixed burnt umber on a medium sable and worked this dark colour against the pales applied in the previous step. Here, I am able to smooth out the initial pale lines as I expressed the dark colour side by side.

I wiped excess paint from the bristle and smoothed out the edges of these contrasting tones. I added more pthalo blue to the pale colours to suggest a chromatic shift in the highlights of the garment. To make the garment appear to 'belong' to the figure wearing it, I softened the neckline of the chemise with a shadow colour comprising a little burnt sienna and white on a clean sable.

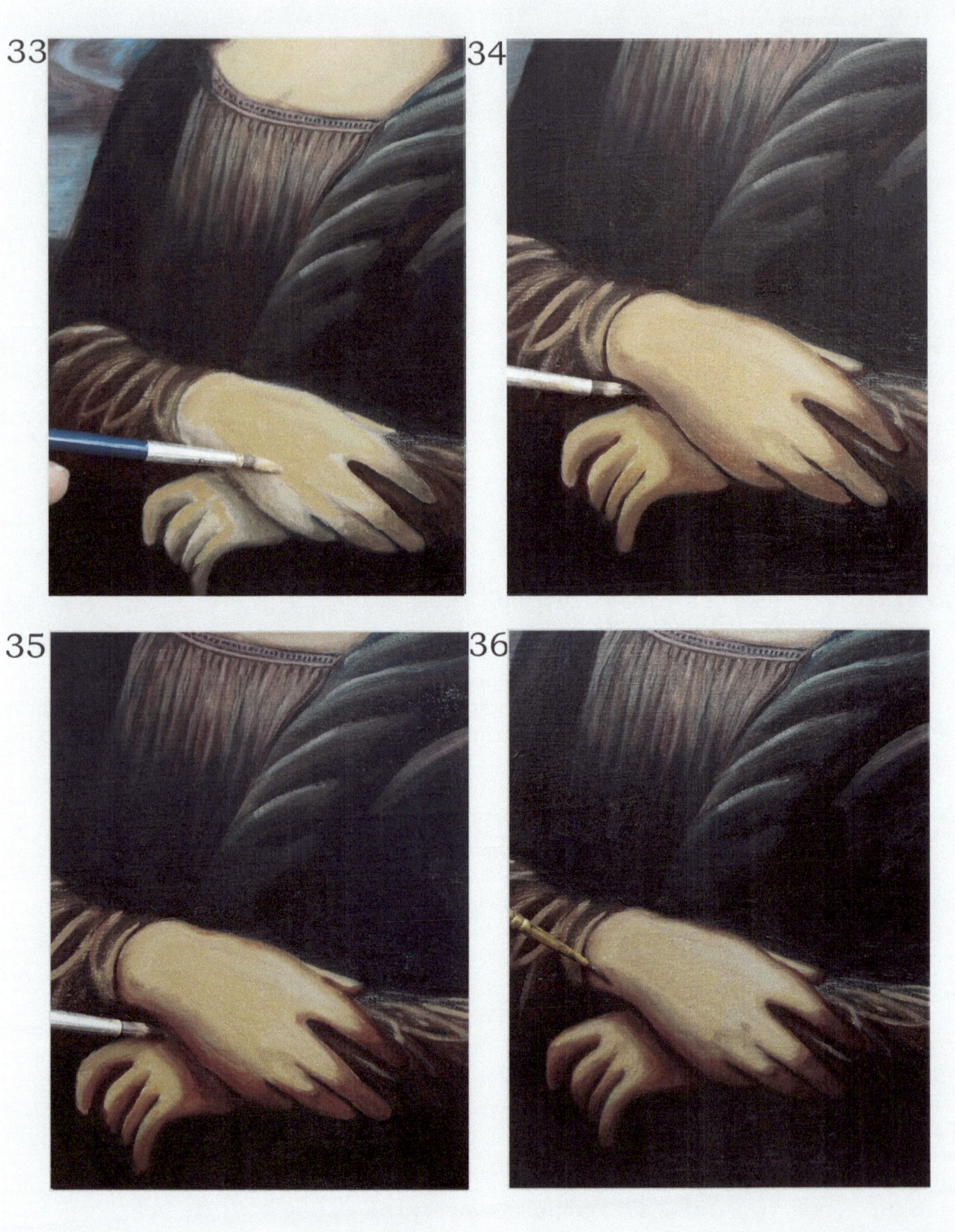

Softening Shadows on the Hands

33 Notice how rough the underpainting on the hands suddenly look once the paint is dry. This is one of the features of alla prima. This second glaze will enrich the colours and smooth out imperfections. To begin with, I mixed cadmium yellow and burnt sienna into plenty of white and dabbed this rich creamy colour over the backs of the hands. Keep checking how this colour appears in relation to the face so that they appear to belong to the subject. I added progressively more burnt umber as I worked towards the fingertips. I smoothed out unwanted brush marks with a clean sable. Care was used not to go over the shadowed areas of the hands.

34 I made preliminary lines around the hands which will be softened as I work over them. Notice the drop-shadow over the left hand. This linear colour comprises neat burnt sienna which will be blended into the surrounding colour to give them form.

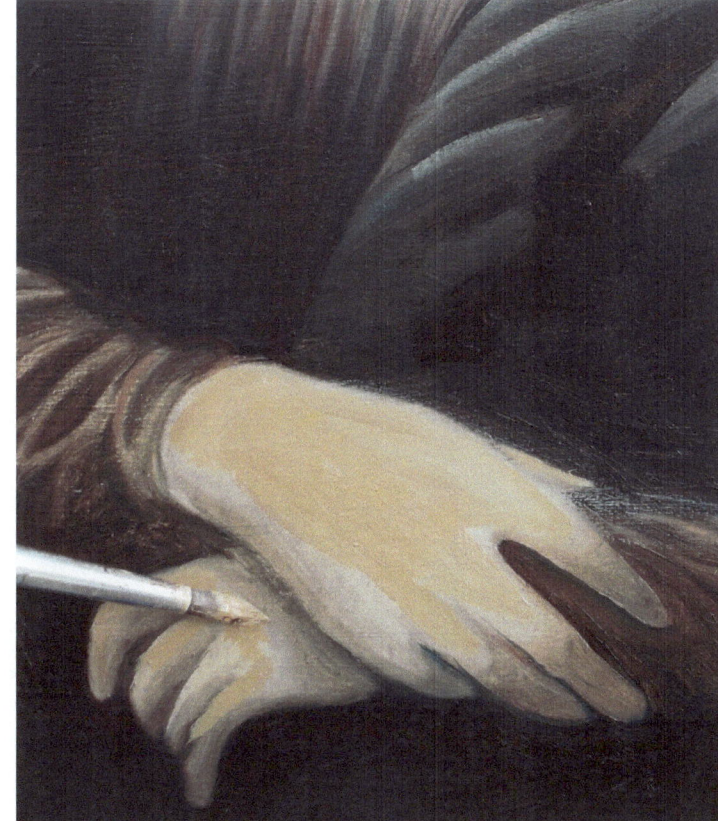

I checked the shapes of the fingers were correct, which is often necessary with each glaze. Never fall into the trap of simply echoing the colour mixes and the lines expressed in the initial glaze or errors will be duplicated. I made modifications to the shadows over the knuckles which will help support the highlights.

Shadows in Foreshortening

35 I added more burnt umber and a little burnt sienna to the shadows where the two hands meet. I wiped excess paint from the brush and softened this shadow colour over the prevailing lighter colour.

Notice how the fingers are slightly in foreshortening due to how they curl slightly inwards. This effect will give the illusion the fingers appear shorter than they actually are. Illustrating shadows will reinforce how they are curled inward. I dabbed burnt umber and a little alizarin crimson to this area. I added a little incremental colour on the joints which was achieved by adding a little white.

36 With a fine sable, I mixed burnt umber and a little alizarin crimson to add a real sharpness to this sepia colour. I was then able to add definition to the outlines of the hands to make them appear to stand out. I echoed this deeper tone over other various contours of the hands, including the finger joints, the upperside of the right hand and the shadow between the hands. When up against a dark backdrop, an incremental colour will often be seen, even if it is very narrow, otherwise, the hands will appear flat, like paper. I finally blended out this sharp, deep brown into the neighbouring flesh colour.

Once done, I put the painting away for a week or so until the paint layer was dry to the touch, ready for the dry brushing the final stage of this sfumato technique.

Stage 4: The Dry Brushing

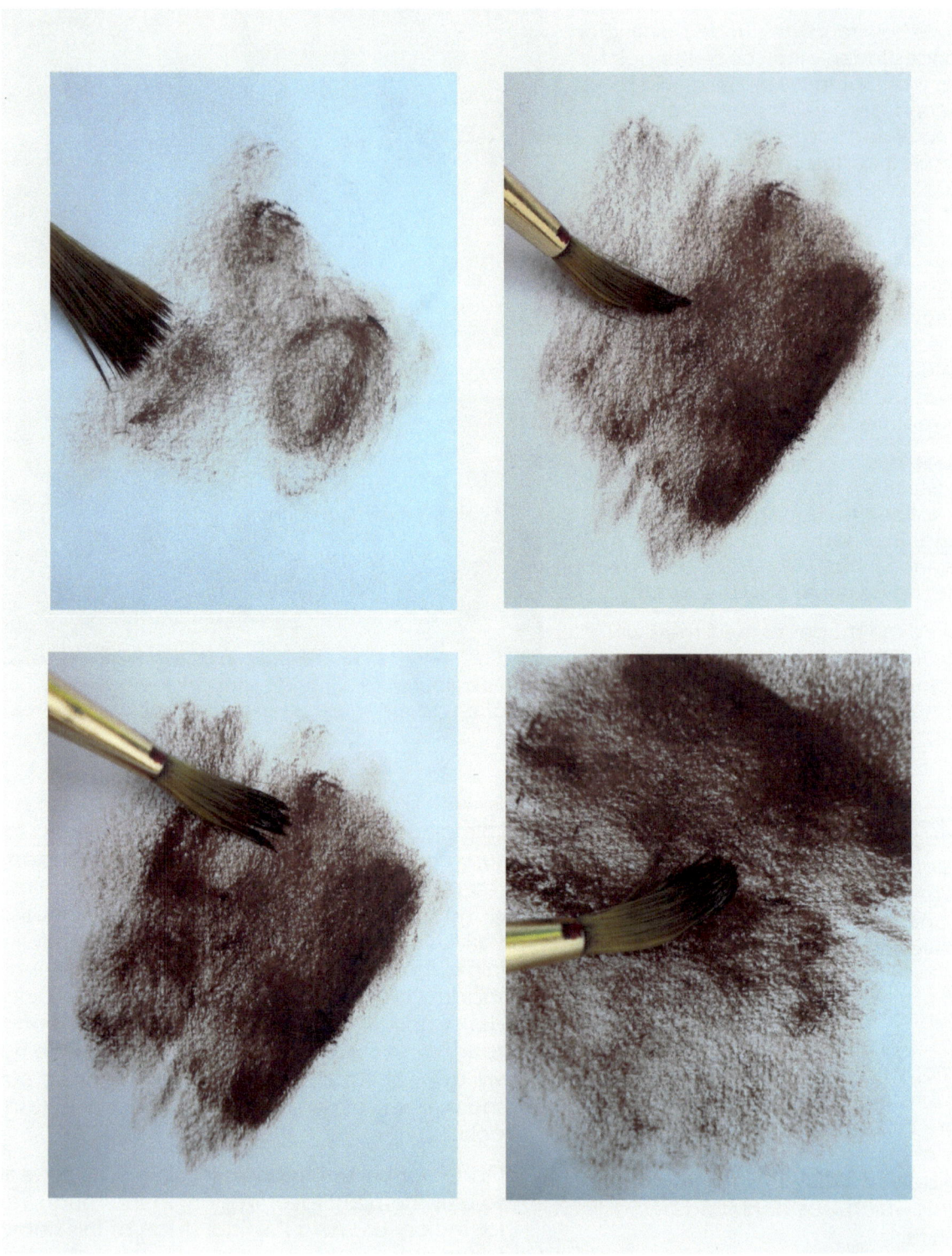

Key to Getting Sfumato Effects

This final stage of the portrait painting comprises the dry brushing, which is great for sfumato. This technique involves an element of shading, rather like with crayons, but in this case, the use of neat oil paint and a stiff brush.

The images show how dry brushing is applied. Here, I have used burnt umber onto a white surface. Applied in this way, this technique can appear unrefined, but on top of a series of glazes comprising similar colours, can give an almost airbrushed feel.

Any colour can be used for dry brushing, including pale colours for highlights or deep colours for delicate shadows. As will be seen on the following steps, it is the shadows that are most significant for effective sfumato.

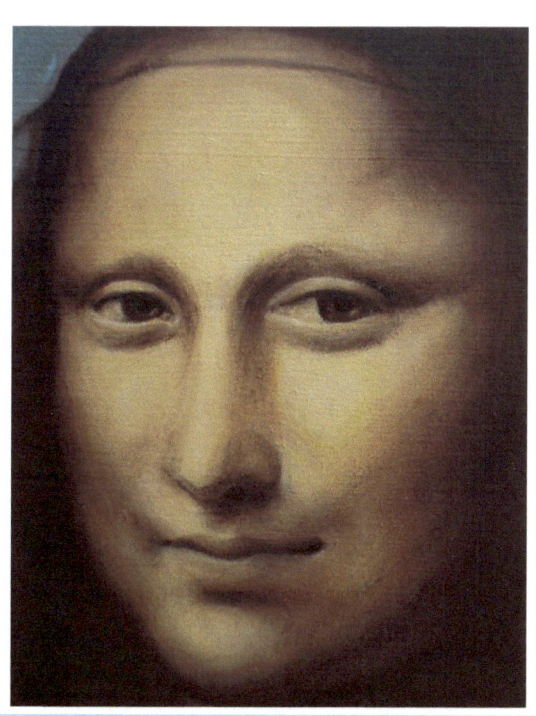

Troubleshooting Sfumato

If necessary, gave a go at dry brushing on a scrap piece of card. Overloading the brush with too much paint will result in an opaque layer that will make shading impossible; similarly, adding artist medium will make it flow in a translucent wash, not good for dry brushing. It is better to put too little on the bristles than too much as more can always be added.

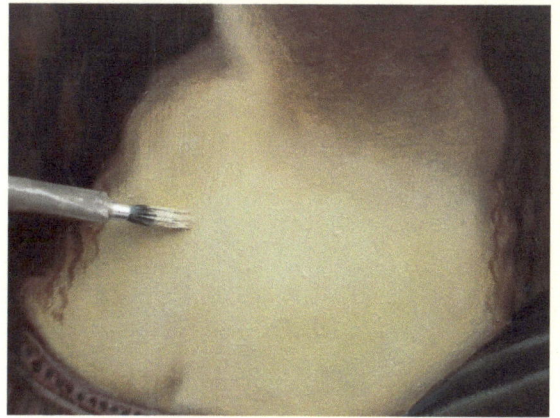

Tint the bristle ends with a small amount of neat paint and then work the paint into the art surface in small movements of differing directions. Working over an area more than once will result in darker shading. If an area doesn't work out, gently wipe off with a clean rag.

Large areas of shadow, such as the left side of the face and the neck, will require a medium bristle or a firm, synthetic sable (soft sables will not withstand the friction on the art surface). Smaller areas such as the brow-bone, beneath the eyes and around the mouth will require a fine bristle, perhaps a no.3 or 6. I have found the smallest amount of paint is needed to make a difference to the skin tone. These upper glazes means a small amount of paint becomes more significant.

Remember to stand back periodically to see how the shapes, contours and outlines of these shadows compare to Leonardo's painting. This final stage is also the final opportunity in putting right areas that could be improved upon. The tonal key, as discussed in the section *Preparing to Paint the Mona Lisa* is important here.

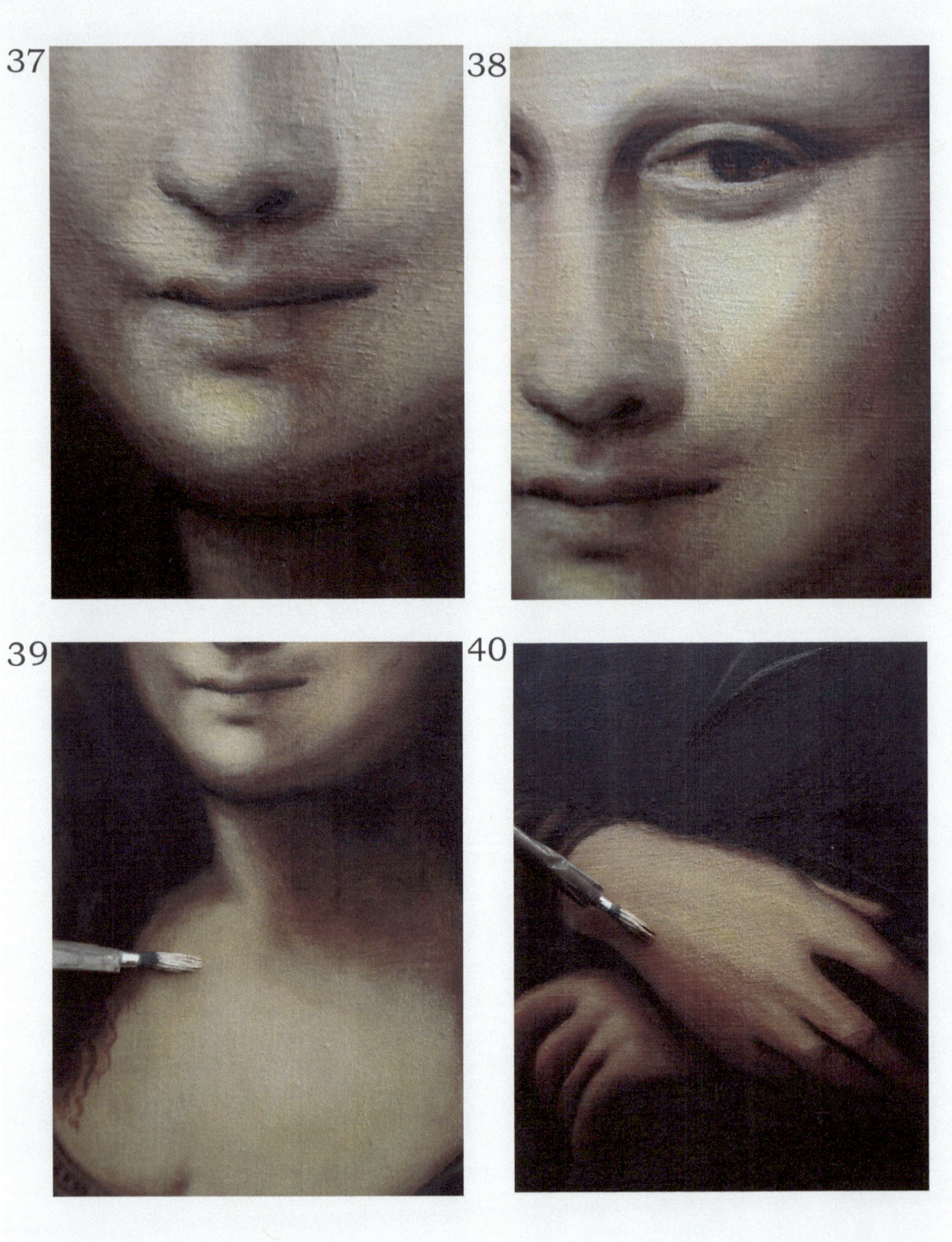

Fine Tuning Highlight and Shadow

37 These final stages of the painting comprise dry brushing over areas of highlights and then shadow. I used separate brushes: one reserved for pales, the other, shadow. Dry brushing is a great way of remedying imbalances in tone, for instance, shadows that appear too dark, pale or of the wrong shape.

As in many portraits in progress, niggles will exist. This is often due to the disparity of how something looks close up and from afar. The best thing to do is to keep checking how these areas appear from different vantage points, close up, far away, upside down and on its side. I made minor adjustments to the shape of the shadows beneath and to the side of the nose, working with the pale colours first. For this, I used small amounts of white and a little burnt sienna and cadmium yellow via a fine bristle. I made light touches to the upper lip, the chin and the nub of the nose. I had also reinforced highlights on the brow and cheekbones via this dry brushing.

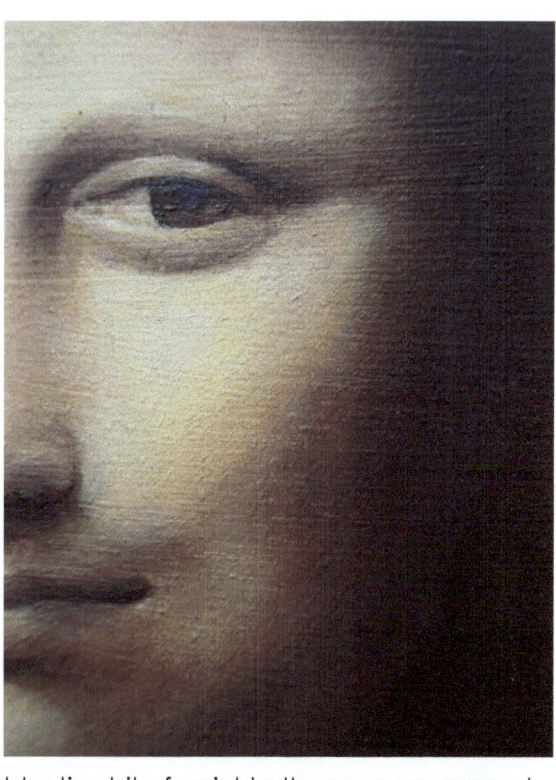

38 As can be seen here, dry brushing does not mean the entire face has to be worked over in the manner of the underpainting and the chief glaze, but select parts. I will add a tiny bit of paint to the area concerned, smudging it out into the surrounding colour with a clean bristle or a cotton bud. Sometimes, nothing beats the fingertips, which I used to smudge the paint out around the cheekbones.

With a separate bristle, I worked a little shadow colour upwards along the side of the nose to the brows, using white with a little burnt sienna and pthalo blue, smudging it out into the highlights. With a fine sable, I reinforced detail on the eyes, drawing pthalo blue and burnt umber over the upper eyelids and the outer irises. I also touched up the pupils. It is important here to make sure the correct portion of the pupil is in view. Here, roughly three-quarters can be seen.

39 I reverted to my 'pale' brush, used in step 37, and touched up the highlights around the chest area. Each layer of paint allows further elaboration upon the shape and nature of highlights. Here, I added a little white and cadmium yellow to the main area, working down towards the cleavage, where I was able to further suggest form. I moved the brush in small, circular strokes for shaded effects. I added a little burnt sienna to soften out these areas of highlights and suggest shadow from the clothing. As can be seen, the slightest adjustment to colour tone will impact upon the apparent contour of an area.

Dry Brushing the Hands

40 I conducted some dry brushing over the hands with the pale brush, working the pale mix over the back of the right hand. I applied light strokes to the backs of the fingers, extending these highlights towards the wrists to suggest tendons. I darkened this light colour slightly in order to touch up the knuckles on the other hand. Again, I did not work over the hands entirely, only the highlights. Suddenly, the colour appears richer and really stands out against the shadow colours. Be careful not to overdo this touching up, or the area will appear overworked. Use economy in brush marks.

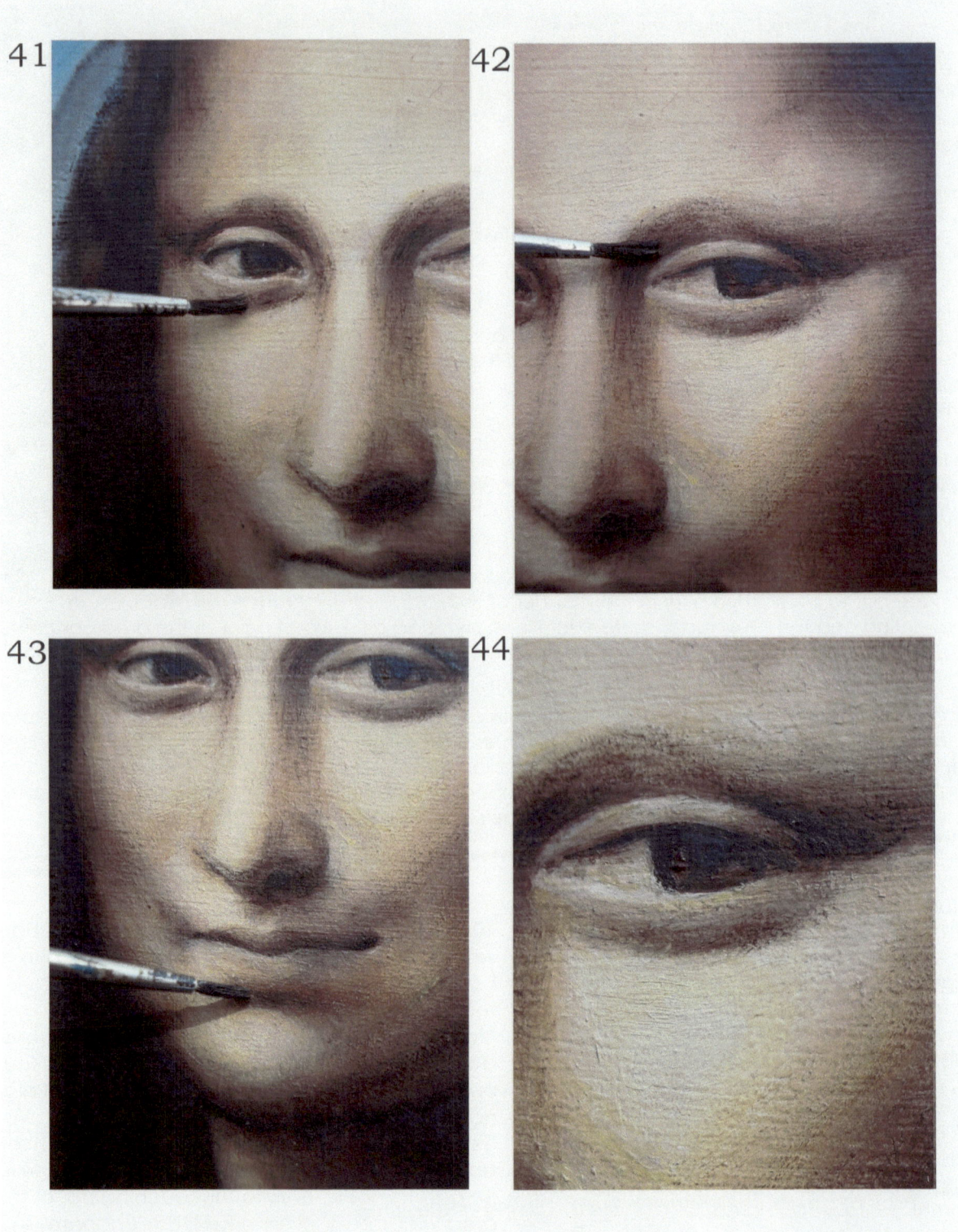

Painting Around the Eyes

41 Now that I had dry brushed the highlights, I could work on the dark sections in similar fashion.

I dusted a fine bristle with a little burnt umber and lightly shaded in the areas around the upper and lower eyelids. These dark areas of dry brushing are crucial in getting sfumato effects. Work a little of the colour on at a time, working more into the area if it is particularly dark.

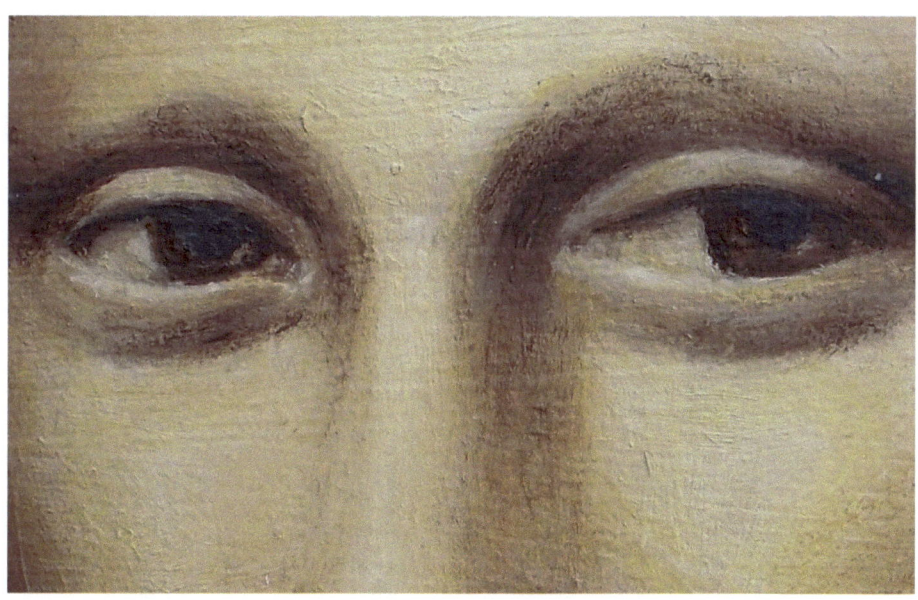

Notice how surprisingly dark the area around the eye socket is, almost black. Sometimes, brutality is needed in areas of fine detail as can be seen here. Notice how the dark brown colour shades out on the outer fringes before it gives way to highlight.

42 I continued to dry brush shadow over other parts of the face to bring unity to the portrait. I moved the fine bristle down the side of the nose and reinforced shadow at the base. I regularly wiped excess paint from the brush before dry brushing more areas.

A little burnt sienna was needed in warmer areas of shadow, as can be seen on the lower cheekbone and the edge of the brow. This final stage of the painting involves 'pulling' shadow areas further inwards to really describe form. I kept viewing the painting from near and far, to ensure I hadn't overlooked any area of shadow.

Subtle Shadows

43 I worked the brush further down the face, 'stroking' the brush against the shadowed areas beneath the mouth and ball of the chin.

Watch out for the shadows that junction on either side of the upper corners of the mouth. These elusive shadows need sensitive treatment. I used a little burnt sienna and a little white, and applied diagonal strokes on either side, blending out towards the edge of the face. I found it necessary to revert to my pale brush to make adjustments to the highlights abutting these shadows.

44 This close up shot shows the rigorous treatment of the paint to illustrate shadow via dry brushing. As can be seen here, small amounts of neat paint had been spread and thinned out via a bristle to suggest the contours around the eye.

Patches of pure burnt umber, burnt sienna and cadmium yellow can be seen partially obscuring highlight. Notice how this echoes the shading technique shown at the beginning of this chapter. Once this dry brushing session was complete, it is possible to put the painting away once more before embarking upon the background.

Stage 5: The Background

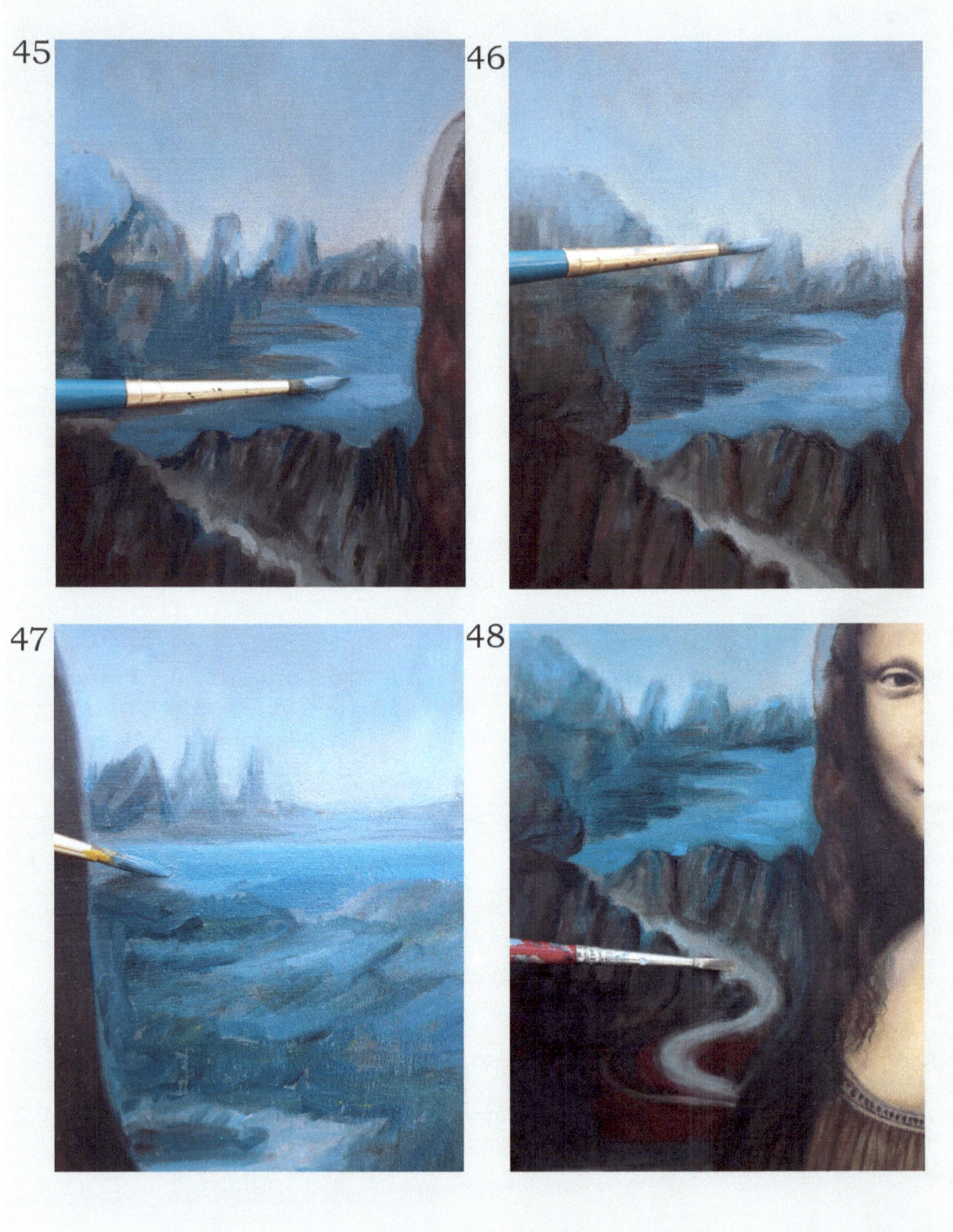

The Background's Final Glaze

45 This third glaze on the background is merely a touching up session, involving some elaboration upon detail and some blending. I decided to inject fresh colours not present on Leonardo's original, which involved using more blues. I worked a medium sable over the canyons, using mostly burnt umber, a little pthalo blue and dabs of cadmium yellow for the greenish areas. More white was injected for the distant crags. I maintained a broken feel for the lake, which was suggested with additional pthalo blue via horizontal dabs of paint.

46 I mixed a little pthalo blue and viridian into lots of white and daubed this colour onto the sky. A little burnt umber was needed to temper the violet hue, as it could appear rather garish in context. I lightened this colour slightly around the horizon, but keeping a soft, broken feel to the sky. I then knitted together the crag colours with the sky via soft, wispy brushstrokes. Care was needed not to work the paint too much or to oversmooth the area or it could lose vibrancy.

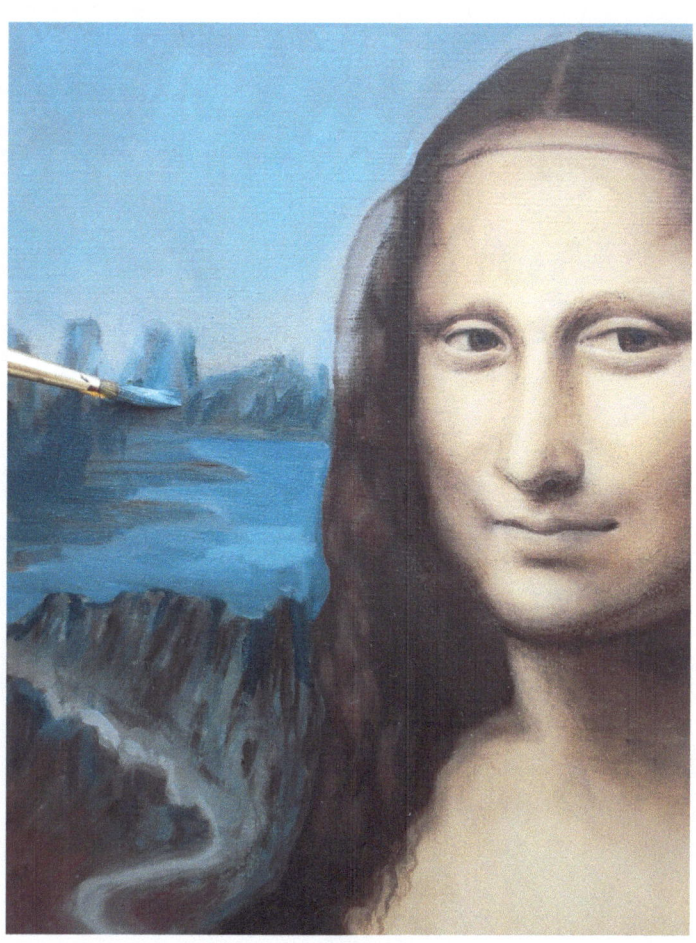

47 I used a similar approach to the other side of the painting, soft blending the crags with the sky, and a broken feel to the lake.

As can be seen here, I have not copied the background exactly, but injected expressive brush marks of my own. Be careful not to fuss too much over areas in the background or it could end up appearing muddy and sapping the focus from the figure. I simplified it into basic chromatic areas and used as few brush marks as possible to express each, making every brush mark count.

I soft blended a little pthalo blue and cadmium yellow with white on the nearer shores of the lake.

Sepia and Blue

48 I added alizarin crimson to select areas further down the painting to bring a focal point to the shift in hue. I then reinforced the textures of the canyon with alizarin crimson, burnt umber and a little pthalo blue, and drew vertical strokes down the canyon walls.

The landscape darkens almost to black in the foreground, making the outline of the figure difficult to make out. I blended this foreground colour, which comprised mostly burnt umber around the figure. The warm sepia hues of the Mona Lisa stand out against the blues in the background.

The Finished Painting

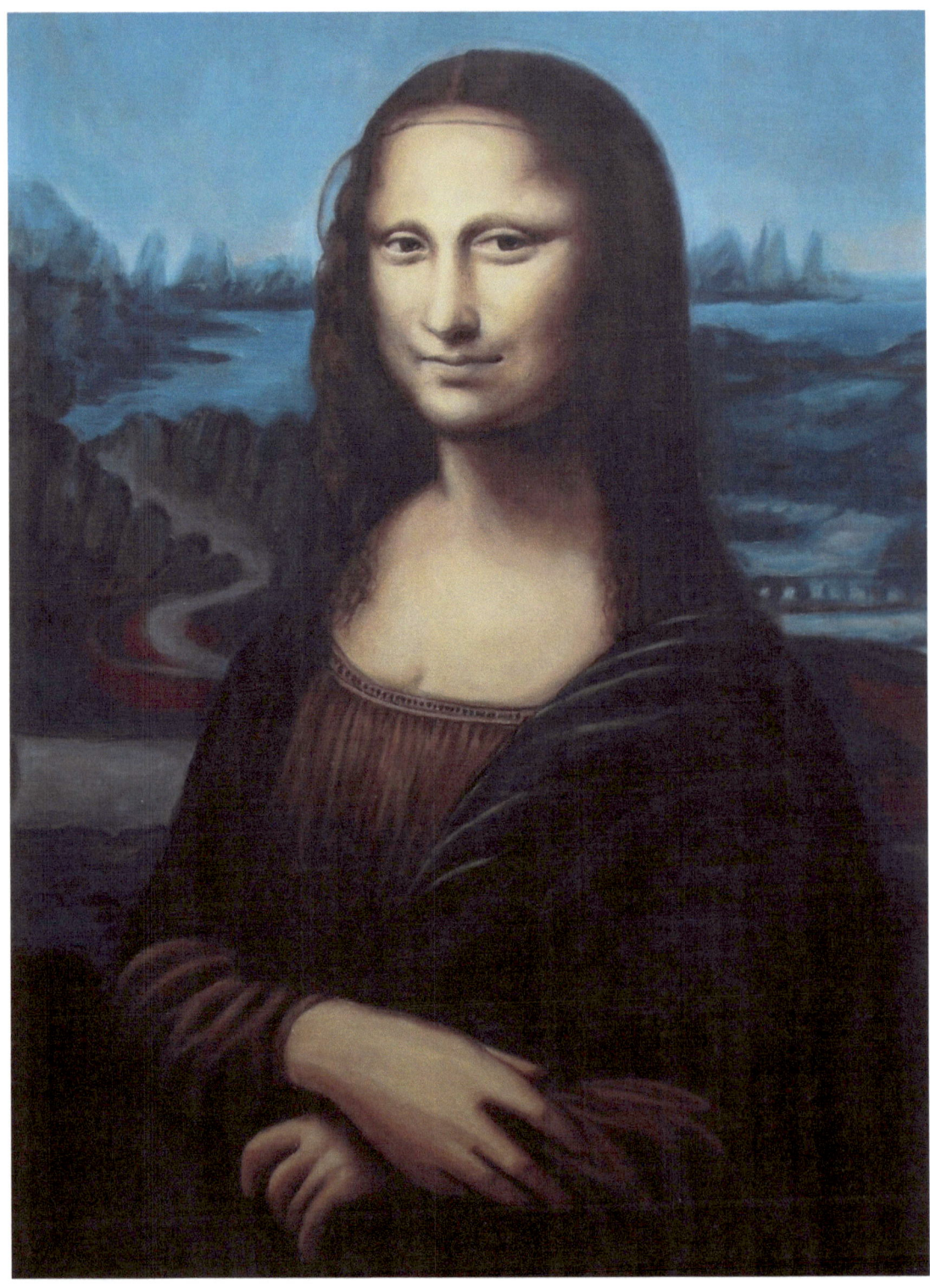

What went Wrong?

Often a painting may fail to go to plan which could cause some frustration, but which forms part of the journey of painting. A particularly ambitious project such as painting the Mona Lisa is likely to bring challenges. What can the artist do when these problems occur and what can be done to prevent them? The following tips might help.

1 Use proper art materials

Never take chances upon a lengthy painting session with cheap paints and materials. Purchase proper gesso size, or the paint might sink into the ground, causing patches to form on the paint surface. A poor ground could also lead to cracking in years to come. Having said this, oils are one of the most robust art mediums in existence, and proper preparations will prevent these problems from occurring. On a similar note, fine sables are worth investing in for high detail and soft blends. Bristle brushes are great for vigorous work, but avoid brushes that molt onto the painting.

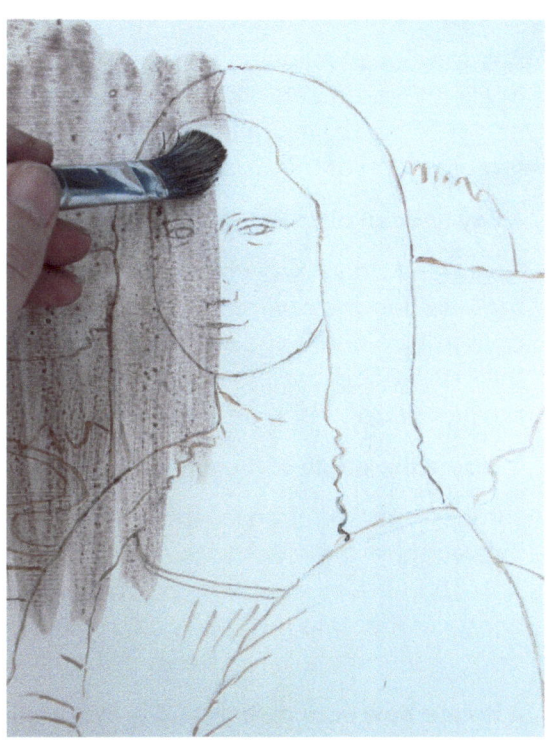

2 Don't rush the underdrawing

As mentioned in the section 'preparing to paint the Mona Lisa,' take ample time over the drawing. The drawing forms the basis on which the rest of the painting is built and a poor drawing can never be remedied by beautifully-applied paint. Make sure the figure inhabits a fair portion of the art surface and is not too near the edges. Work lightly at first until confident the lines are accurate enough. Detail is not important, but accurate plotting. View the drawing stage as a separate project to the painting rather than something to get out of the way quickly.

3 Ensure the underglaze is dark enough

A translucent glaze needs surprisingly a lot of pigment to create a mid-tone on a white painting surface. A diffident approach could result in an overly-pale ground creating a misleading impression of the oil colours' tones when they are applied. Pale colours will appear dark, causing the artist to believe they are dark enough to express shadows. This could result in a painting with a pale tonal key overall and featureless highlights. Ensure the underglaze is quite deep in colour. If necessary, apply a second glaze. This will make possible accurate keying in of tones as the painting progresses.

4 Complete a blending session whilst the paint is workable

Blending shadows and highlights on the face should be completed whilst the paint is wet. Leaving it unfinished for another day could lead to patchy-looking blends over the face, not good for sfumato. The only way round this is to work over the face in an unnecessary glaze as colour matching a glaze that is already dry is virtually impossible. This will cause wasted time and frustration with a negative painting experience.

5 Observe how the facial features relate to one another

Pay special attention to how one facial feature links to another, rather than view them as separate entities. Close observation will reveal that the eyes are linked to the temples via patches of shadow; the edges of the lips link to the jawline via ghostly strands. Even the highlights are linked between facial features such as the Cupid's bow and the cheekbones.

6 Pay special attention to the eyes

Notice the degree at which the pupils and irises are in view. Too much will create a startled expression; too little and the portrait will look sleepy. Dispel preconceptions about the eyes. The whites for instance are similar in hue to the surrounding flesh tones. The areas around the eye sockets are almost as dark as the hair. Notice also the deep shadow over the lower eyelids and the highlights on the rims. Don't take a diffident approach here; express the shadows as dark as they appear in the painting.

7 Ensure the angle of the nose and the face are in accordance with one another

The beginner will often inadvertently illustrate the nose as a full-on aspect upon a portrait that is in three-quarter view. Both nostrils will often not be visible. Shadows will appear softer on one side of the nose than the other. The nub of the nose will not appear symmetrical. Watch out for the angle of the bridge of the nose that slants at a subtle yet crucial angle. An angle too vertical will make the portrait appear snub-nosed. Too steep an angle will result in a beaky nose; neither is desirable on this portrait.

8 Notice how lines differ in width, shape and softness

No lines exist here of the same width and definition. This is particularly important on the mouth. Notice how the seam of the mouth varies in contour and outline from one side to the other. Some will blend out into the surrounding lip tone, others are more definite. If an area of the portrait appears to jar in some way, a harsh line will often be the culprit. Blend out or remove with a rag. View apparent lines as marks, rather than as a boundary between one feature and another.

9 Don't treat the background as unimportant

A lovely portrait can often be ruined by a rushed background, courtesy of an artist keen to finish the painting. Don't simply fill in the gaps around the figure. Treat the background as an element of equal importance. If necessary, complete on a separate day. The background can impact upon the appearance of the figure. A dark background will bring out the highlights on the face; a paler background will make the figure appear more brooding. I aimed for a background of a similar tonal key to the figure, with deep darks and pale highlights. This helped bring unity to the painting. Fortunately, the background to the Mona Lisa possesses scope for interpretation. The artist may copy it faithfully, use a loose approach or employ high detail. Making such considerations will pay off.

10 Find the source of niggles and correct

Don't let niggles pass, as they will continue to niggle. Pinpoint the source of the problem and then put it right. This will mean getting up and standing some distance from the painting, viewing it from different angles, upside-down or through a mirror. A niggle might not always reveal itself until some time has elapsed between viewing the painting again. Over-familiarity with a painting will cause problems to become invisible. I had a few niggles about the area around the nose and the mouth. My solution was to paint them whilst the painting was upside down or on its side.

Glossary

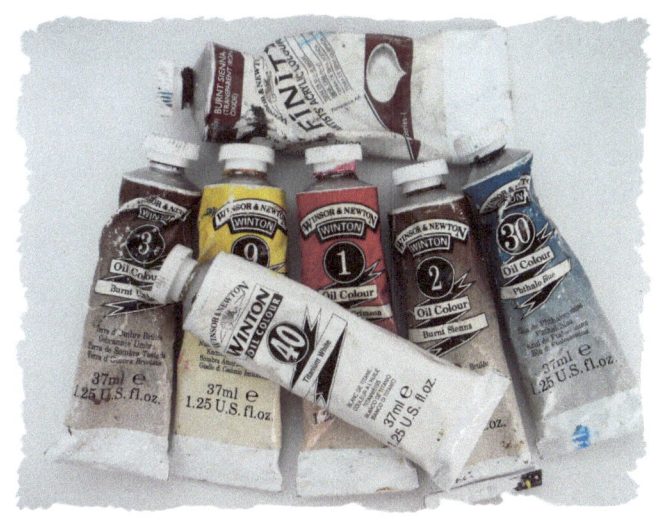

Acrylic paint: A water-soluble paint made from a polymer that dries water resistant. Unlike watercolour, opaque effects can be achieved as well as washes. Acrylic paint is useful for applying the underglaze to the oil painting.

Acrylic polymer primer: Sometimes termed 'acrylic gesso,' a water-soluble paint that dries water resistant, making it the most convenient sealant (or size) for oil painting supports such as canvases or panels. A distinction must be made between traditional gesso, which is whiting suspended in glue.

Alla prima: A painting completed in one sitting as opposed to layers.

Bristle: A stiff brush such as hog hair for robust brushwork and impasto.

Canvas: An oil painting support made from unbleached hemp or a similar fabric.

Complementary colour: A colour situated on the opposite segment to any given colour on the colour wheel. Red, for example is the complementary to green.

Filbert: A flat bristle brush with a head that forms an oval shape.

Flat: A flat bristle brush with a head that forms a wedged shape.

Gesso: Ground white pigment suspended in glue which is applied to the painting support prior to oil painting.

Grid method: A means of scaling up (or down) a drawing by plotting points from an image overlaid with a grid onto the drawing surface possessing a similar grid of larger (or smaller) proportions.

Glaze: (In painting) a layer of paint.

Impasto: The application of thick paint.

Impasto medium: An alkyd-based medium that adds bulk to paint for impasto techniques.

Imprimatura: See underglaze.

Linseed oil: Extracted from the linseed, the carrier of oil paint. When used as a medium, it adds gloss, transparency and flow.

Opaque: A dense layer (of paint) that cannot be seen through.

Panel: A firm, rectangular-shaped support for oil painting, usually wood, which might be hardboard, plywood or MDF.

Round: A brush that tapers to a point for applying detail.

Sable: A soft brush made from the fur of the sable, a small mammal. A cheaper alternative is available in the form of a blend of the sable and a synthetic substitute.

Sfumato: From the Italian word *sfumare*, this means to evaporate like smoke. Sfumato is a chief painting practice of the Renaissance where the contours of the face are hidden in soft shadow. Leonardo da Vinci's the Mona Lisa is the most noteworthy example.

Solvent: A thinner for oil paint which is also used for cleaning the brushes. Solvents designed for artist use (not industrial) should always be used for oil painting. I use Sansador.

Support: When pertaining to oil painting, a support is the surface onto which the oil painting is applied. Suitable supports include canvas, wood, card or thick paper. The support must always be sealed with a gesso or similar sealant prior to oil painting. I use acrylic gesso primer.

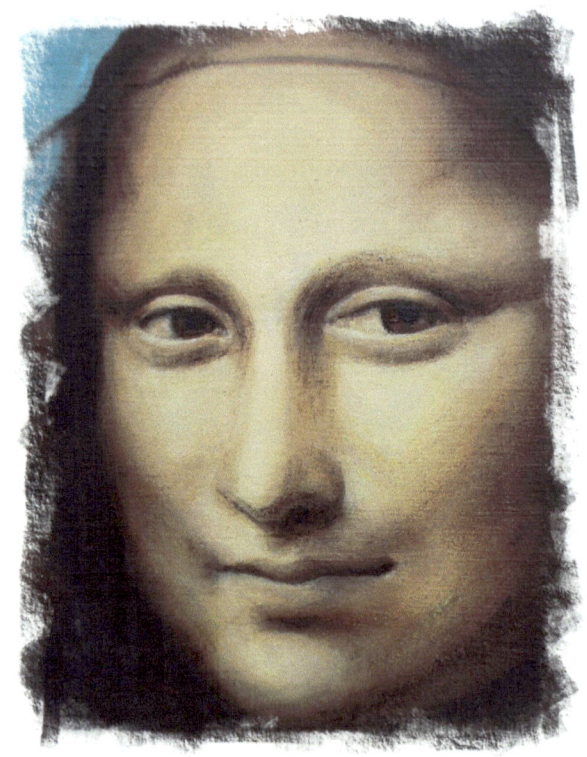

Translucent: A thin layer (of paint) where detail beneath can be seen beneath.

Underdrawing: A rudimentary drawing that forms the basis of the painting.

Underglaze: sometimes known as an imprimatura, a layer of paint applied prior to the oil painting to kill the off-putting whiteness of the art surface. The underglaze can be used to add mood to the finished painting and can be any colour which might be opaque or translucent. I use acrylic paint for my underglazes.

Other Books by the Author

I have practiced oil painting from the age of six and have since been involved in countless projects and commissions. A graduate from Kingston University, Surrey and with a PCET teaching qualification from Warwick University, I have won competitions, taught life drawing and have written numerous articles on teaching art.

An overview of all the following books can be found and purchased on my Oil Painting Medic Blog.

Art Books (Select books available on Kindle, small & large Edition)

Why do My Clouds Look like Cotton Wool? – Plus 25 Solutions to Other Landscape Painting Peeves

Why do My Ellipses Look like Doughnuts? – Plus 25 Solutions to Other Still Life Painting Peeves

Why do My Skin Tones look Lifeless? – Plus s 25 Solutions to Other Portrait Painting Peeves

The Ultimate Oil Painting Solution: for Landscape Art, Portraiture and Still Life

Landscape Painting in Oils: 20 Step by Step Guides

The Artist's Garden in Oils: 18 Step by Step Guides

Portrait Painting in Oil: 10 Step by Step Guides from Old Masters

Skin Tones in Oil: 10 Step by Step Guides from Old Masters

Oil Painting the Mona Lisa in Sfumato: a Portrait Painting Challenge in 48 Steps

How Can I Inspire my Painting Class? (Lesson Plan Ideas for Oil Painting in Post Compulsory Education & an Essential Guide to Teaching)

Draw What You See Not What You Think You See

Oil Paintings from Your Garden GMC Publications Ltd

Oil Paintings from the Landscape GMC Publications Ltd

Illustrated Children's Books

Katie's Magic Teapot and the Cosmic Pandas

Katie and the Cosmic Pandas' Deep Sea Voyage

Katie's Magic Teapot Omnibus Edition

Ben's Little Big Adventure

www.ingramcontent.com/pod-product-compliance
Lightning Source LLC
Chambersburg PA
CBHW050833180526
45159CB00004B/1892